Acknowledgements and Copyright

We would like to acknowledge the following people for their contributions and encouragement in creating this book: Jane Bradley and the staff at Bristol Central Library for generously allowing access to their rich collection of historical images; Andy King, Curator of M Shed Museum and an authority on the docks; Julia Carver, Curator Visual Art at Bristol Museum & Art Gallery; Claire Hedley for help with proofreading, and all the photographers who have allowed their work to appear in this book.

A very special thank you to Clive Lewis of UK & European Investments for his help in bringing this project to publication.

Produced by The Everything Curious Company, Unit 130, 3 Edgar Buildings, George Street, Bath, BA1 2FJ, United Kingdom.

Historical images © 2012 Sourced from Bristol Central Library and www.bathintime.co.uk.

Contemporary photographs © 2012 Chris Bertram, Ian Briggs, Dan Brown, Norman Date, Myk Garton, Paul Green, Tim Green, Lee Jordan, Henry Laws, David Martyn, Paul Stokes, 'Aztec West' and Christina West.

Publisher's Note:
The inclusion of a photograph in this book does not necessarily imply unrestricted public access to the location illustrated.

Text © 2012 Andrew Foyle

Published by The History Press.

Design by Christina West.
www.christinawest.co.uk

(front inside cover) Samuel and Nathaniel Buck, *The North West Prospect of the City of Bristol from Brandon Hill*, 1734, copper engraving

Select Bibliography

Binding, John, *Brunel's Bristol Temple Meads,* Oxford Publishing, Oxford, 2001.

Foyle, Andrew, *Bristol – Pevsner Architectural Guide*, Yale University Press, London, 2007.

Foyle, Andrew and Pevsner, Nikolaus, *The Buildings of England; Somerset: North and Bristol*, Yale University Press, London, 2011.

Gomme, Andor and Jenner, Mike., *Bristol; An Architectural History*, Oblong Publishing, Wetherby, 2011.

Ison, Walter, *The Georgian Buildings of Bristol*, Kingsmead Press, Bath, 1978 (reprint).

Jones, Donald, *A History of Clifton,* Phillimore, Chichester, 1992.

Kelly, Andrew and Melanie, (eds.), *Brunel: In Love with the Impossible*, Bristol Cultural Development Partnership, 2006.

King, Andy, *The Port of Bristol*, Tempus, Stroud, 2003.

Latimer, John, *The Annals of Bristol,* Kingsmead Reprints, Bath, 1970.

Matthews, William, *Matthews's New History of Bristol, or Complete Guide and Bristol Directory...*, Bristol, 1794.

Stoddard, Sheena, *Bristol Before the Camera: the City in 1820-30*, Redcliffe Press, Bristol, 2001.

Printed and bound by Print Best Trükikoda in accordance with the ISO14001 environmental management system using vegetable based inks.
The paper is made entirely from virgin pulp derived from forests managed under the Forest Stewardship Council ® rules.
The printer holds the FSC chain of custody certificate TT-COC-003664. By undertaking all printing and binding on one site, further environmental savings in terms of transport and energy are achieved.

Bristol

City on Show

Text by Andrew Foyle

Principal contemporary photography by
David Martyn

Additional contemporary photography by contributors

Historical images from the collection at Bristol Central Library
and from **www.bathintime.co.uk**

Published by The History Press, The Mill, Brimscombe Port, Stroud, Gloucestershire, GL5 2QG
www.thehistorypress.co.uk

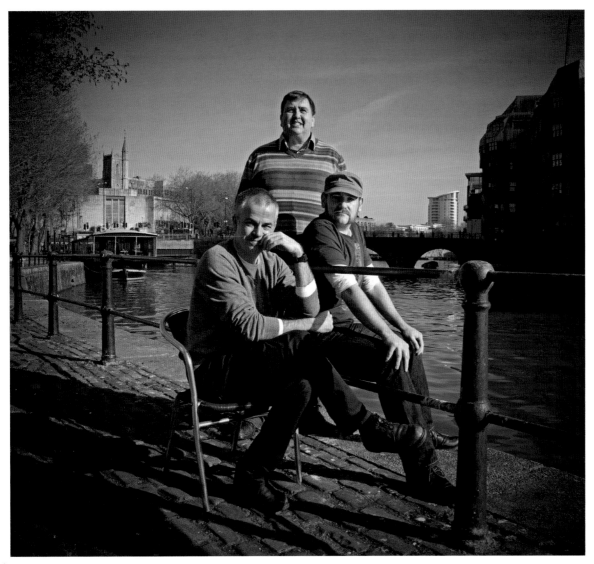

The team behind the book, from left to right: Dan Brown, Andrew Foyle and David Martyn on Welsh Back, 2012, photograph

Foreword Dan Brown

This, the second book in the *City on Show* series, *Bristol – City on Show* combines a compelling mix of curious historical images with the best contemporary photography of today, all taken by local people who know the city best.

Setting out to create this book, we wanted to show what makes Bristol the great city it is. From the creative and diverse to the philanthropic and historic, it is clear that there are so many ways to celebrate this unique community in its wonderful setting. Our biggest challenge was choosing how to encapsulate the rich variety of life, incredible span of architectural periods, and important history, as comprehensively as possible, whilst knowing that the abundance of material would mean that inevitably we would have to leave something out.

An essential ingredient for this book are the historical images, and we were extremely lucky to be able to study at length the Braikenridge Collection at Bristol Central Library, an important historical record of Bristol in the 19th century. The library's collection also yielded many wonderful photographs which perfectly illustrate the many changes that occur as trade, industry and manufacturing give way to financial services, leisure and heritage.

The majority of the contemporary photographs are by local architect David Martyn who has lovingly recorded his city all year round for many years; the contemporary photography we have selected conveys his deep understanding of the subject and use of conditions that we believe perfectly capture its raw essence. Offset against their historical counterpart, this blend of old and new reminds us of how much change has taken place, as well as the historic fabric that we have inherited.

Whilst being a highly visual book, respected local architectural writer Andrew Foyle has woven a fascinating historical narrative around the images to inform and entertain the reader, taking them on a journey through the ages and areas of the city.

On a personal note, the inspiration for this book came from a dear friend and neighbour Euan Cresswell, who died after a short illness in September 2010. He promoted innovation in building design, perhaps best illustrated with the new headquarters for the Environment Agency, one of the UK's most energy-efficient office buildings in Deanery Square, a building that, tragically, reached cmpletion only months after he died.

This book is dedicated to his memory.

Euan Cresswell 1960 – 2010

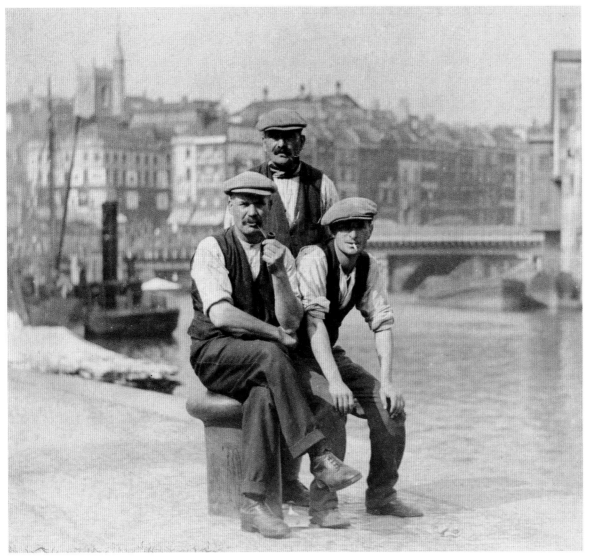

Dock workers on Welsh Back,
c.1920s, photograph

Introduction Andrew Foyle

Bristol's origins are ill-documented and obscure. There was no Roman settlement of any size. The late Saxon era seems to have seen the settlement of today's city, formed around the bridge over the Avon and the shallow tidal harbour downstream. There were earthen walls with gates and churches encircling the area around Corn Street, High Street, Wine Street and Broad Street, with the High Cross planted later at the crossing.

Despite these defensive walls and the castle which followed to the east shortly after the Norman Conquest, Bristol was always a place of trade. The sheltered inland port was ideally situated for trading with the Cornish peninsula, the coasts of Devon, Somerset, with Ireland, Wales and the more northerly ports of the west coast of England.

Surprisingly early, by the 11th or 12th centuries, Bristol was trading too with Iceland, Scandinavia, France, Spain, the Mediterranean and North Africa. Its major export was wool from the Wiltshire Downs, the Cotswolds and the Mendip Hills. Later, Bristol wove the wool into cloth and exported that; it was in high demand throughout Europe. Goods such as wine, iron, leather, oil and agricultural produce were imported and sold. The manufacture of soap was an important trade.

By the end of the 14th century, Bristol was the second city after London, a position for which it vied with Norwich and York. Late Medieval Bristol was endowed with great wealth, as evidenced by the riches of its Gothic churches. It was created a city and county in its own right by charter of 1373. The 16th and 17th centuries saw substantial growth of population and trade, with expansions towards Hotwells, Bedminster, St Michael's Hill and to the east in Broadmead and Old Market.

By the late 17th century Bristol was trading with the new colonies in the Americas and the Caribbean and its shameful role in the slave trade began. The wealth from this trade was largely responsible for a second Golden Age, c.1700-1760, with new products such as tobacco, sugar, brass, porcelain and glass playing important roles, and the Hotwells spa boosting its fashionability. By the late 18th century, Bristol was losing out to the industrialising cities of the north and to the port of Liverpool. The creation of the Floating Harbour (1804-9) made the process of loading and unloading ships more efficient, but it came too late to reverse the trend. Bristol maintained its varied industrial and commercial profile until after the Second World War, but its profits and population growth were less spectacular than, say, Manchester, Birmingham or Leeds.

Post-industrial wealth has been based upon Bristol's geographical position as a centre for communication and distribution and upon its expertise in the technology, aerospace and financial sectors. The large student population (now c.60,000) provides a steady supply of potential employees in these highly specialised occupations. Leisure plays an increasing role in the city's economy, boosted by its reputation for the arts, museums, theatre, music, and a thriving nightlife. Media contributes much to its profile, with the BBC Natural History Unit and Aardman Animations perhaps the best-known exponents. The 70 acres of water in the heart of Bristol is the focus for sporting activity and for the important business of relaxing, eating, drinking and browsing along the quaysides.

There is much else that can be said in Bristol's favour. Its slightly edgy, alternative, eco-friendly profile is strengthened by two city farms and its sustainable transport initiatives. Its character is explorative, independent and laid-back. Many arrive to study or to work for a year or two before moving on; fewer are willing when the time comes to give up its high quality of life, and many stay for a lifetime.

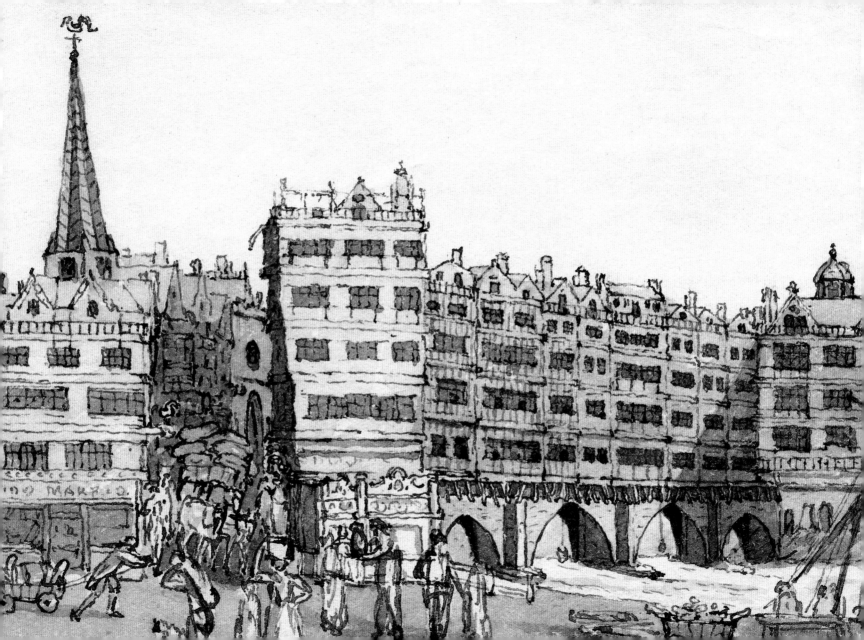

(facing) *Bristol Bridge from Welsh Back,* **c.1750, pen and wash**

Bristol derives from the Anglo-Saxon word *Brycgstow*, or 'the place at the bridge'. Perhaps in the 9th century the Saxons built the first bridge, at the lowest crossing point of the tidal River Avon, and the settlement quickly expanded around it. That wooden bridge was rebuilt in the 1240s, with four stone arches. By about 1300, tall timber-framed shops lined the thoroughfare on both sides, taking advantage of the fact that all travellers from the south had to cross over here to reach the city. Many commentators

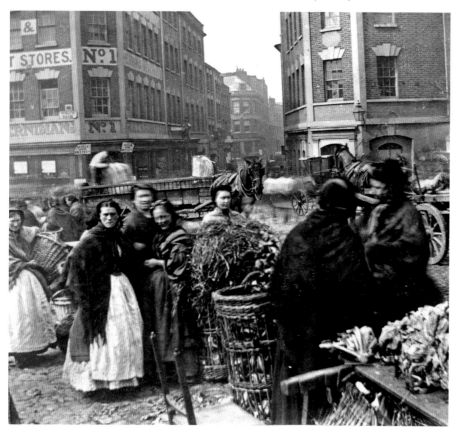

likened Bristol Bridge to Old London Bridge. This delightful pen sketch (facing) shows the west side of the medieval bridge, with, to the left, the medieval spire of the church of St Nicholas and a glimpse of the city gate which was built into its east end. It was rebuilt again in its present form in 1762-8.

The fish market was traditionally held beside Bristol Bridge and opposite St Nicholas church, where a group of businesslike market women congregate in this 1860s photograph (left).

(left) *Fish market at The Back,* **c.1860, photograph**

Despite the removal of the fish market to Union Street by the late 18th century, 'salmon, cod, mackerel, herrings, plaice, flounders, oysters, crabs, lobsters, sprats, shrimps etc. brought by boats in great quantities' continued to be sold by Bristol Bridge. Shopkeepers, warehousemen, ship owners and those engaged in a myriad associated trades clustered around the bridge. By the 18th century nearby Corn Street was the financial heart of the city, and the most splendid bank buildings are still to be seen there (below and facing). The Exchange had been sited at the top of Corn Street since the Middle Ages, and from 1743 occupied splendid new premises designed by John Wood of Bath. Outside are four bronze nails, memorialising the centrality of Bristol's trade and the persistent preference of its merchants for dealing outside the Exchange rather than inside.

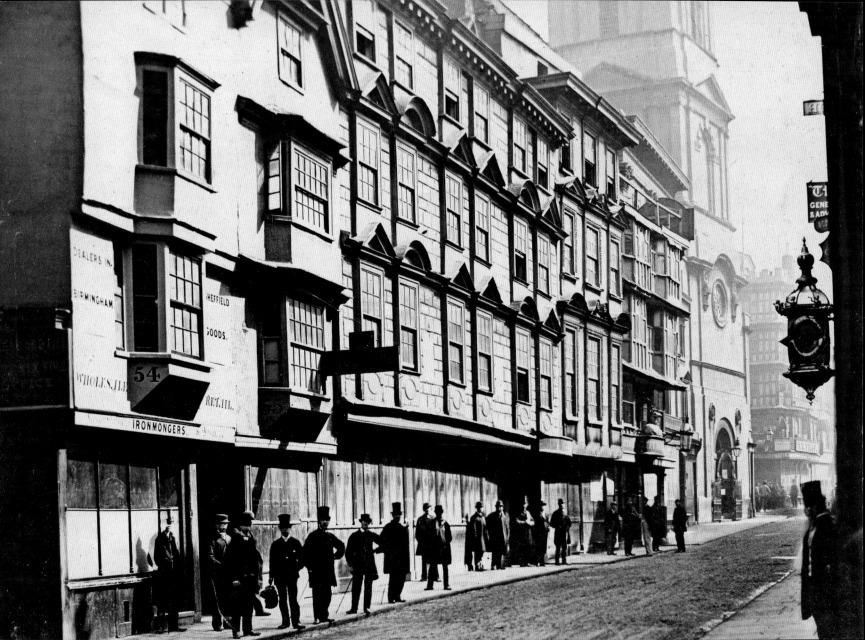

(facing) *Broad Street,* **1860, photograph**
(below) *The Old Council House, Corn Street,* **1911, photograph**

Broad Street forms one arm of the four streets which met at the site of the former High Cross. At its south end stands Christ Church, of Saxon origin and probably one of the city's oldest churches. The imposing timber-framed late-17th-century building with ranks of pedimented windows was the White Lion, one of the foremost inns. Its position adjacent to the Medieval Guildhall and opposite the Council House (which superseded the Guildhall in 1827) ensured it hosted many a corporation dinner awash with turtle soup and madeira. Pictured below, the Council House is lavishly dressed with the flags, swags and strange drapery deployed for great Royal and national events – on this occasion the Coronation of King George V in 1911.

(right) *Richard Hardwidge Esq. alias Dickey-All-Hot, Hot! The celebrated seller of apple dumplings in the Pithay,* **c.1825, coloured engraving**

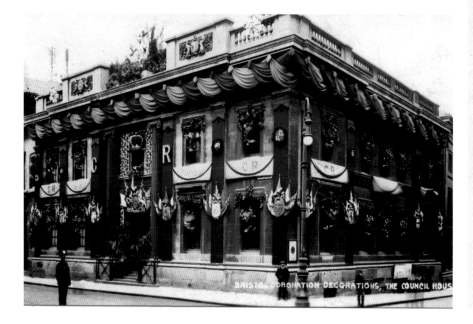

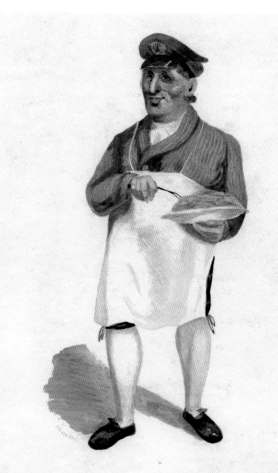

RICH^D HARDWIDGE, Esq.
alias
"DICKEY-ALL-HOT, HOT!"
The only Manufacturer to their MAJESTIES the now
of the
"ROYAL JACKS" & "PATENT APPLE DUMPLINGS,"
at his celebrated "Eating-Rooms" in the
PITHAY,
Bristol; Printed, Pub^d & Sold by T. Steele, S^t Stephen's Avenue.

(below) *The Lantern Room,*
Old Council House, Corn Street,
photograph, 2011

Eating out is nothing new, although today's welter of restaurants, cafes and takeaways is new. Dickie-All-Hot, Hot (p.13) was the tradename of Richard Hardwidge, who in the days of George IV and the Sailor King sold apple dumplings called Royal Jacks at his eating rooms in the Pithay. In 1668 Samuel Pepys dined on cold venison pasty, strawberries and 'above all' the sherry known as Bristol Milk. The elegant Perpendicular porch of St Stephen's church is pictured right c.1876. The merchant John Shipward was a major benefactor of the church's rebuilding in the mid-15th century. Victorian

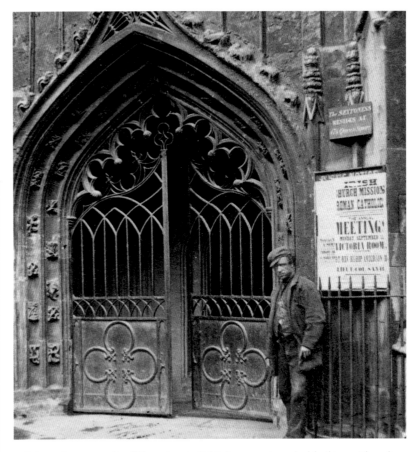

religious duty was of a different sort: Bristol was a stronghold of Low Church evangelicalism. This unknown man, who appears to be perhaps a vagrant or day labourer, stands below an announcement for the annual meeting of the Irish Church Missions, an organisation intent on protestantising Ireland.

(above) *St. Stephen's church entrance,* **1876, photograph**

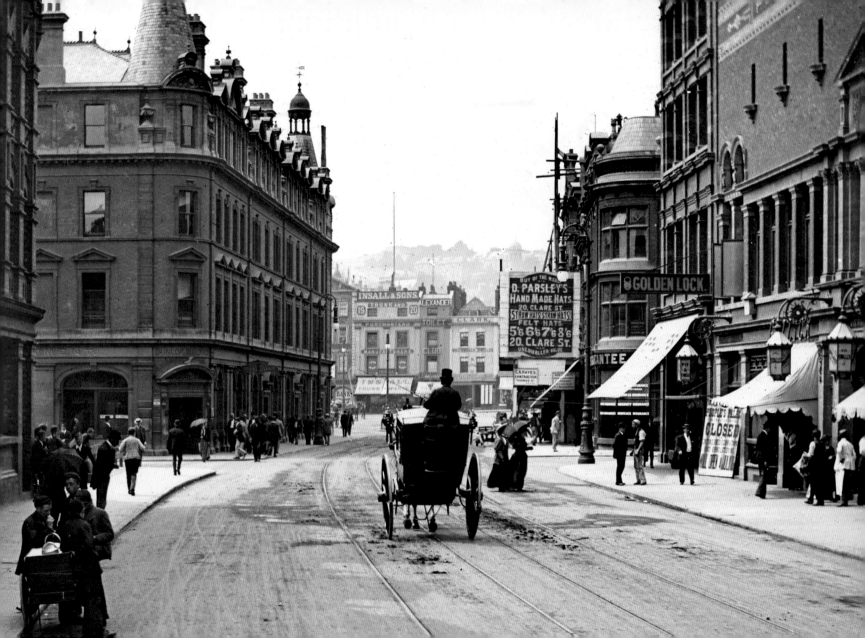

(facing) *Baldwin Street looking towards The Centre*, c.1895, photograph

Bristol's geography has for centuries constricted its growth, especially in the old city. Baldwin Street was cut through run-down medieval tenements in 1879-80, linking Bristol Bridge with Broad Quay. Its late Victorian brick shops and offices were already being rebuilt by 1895, when the Capital and Counties Bank was surrounded by hoardings for an extension. In the right foreground, Bristol's largest music hall, the People's Palace (1892), was already closed for refitting. In 1911, the medieval structure of St John's Arch in Tower Lane (right) was demolished for enlargements to Fry's chocolate factories. It was typical of Bristol until the Second World War that factories, shops, houses and public buildings were squeezed in cheek-by-jowl throughout the city.

(right) *Workmen demolishing St John's Arch* **(note ghost image of boy in bottom left), 17 March, 1911, photograph**

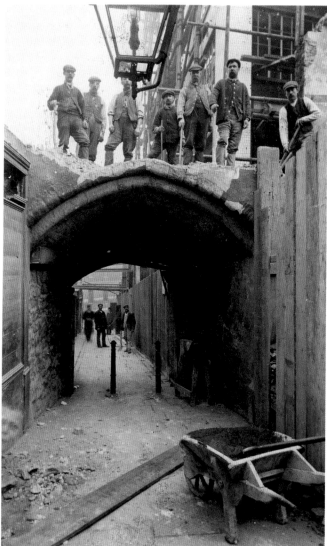

(left) **Frederick George Swaish (1879-1931)**, *Building of the Great Keep of Bristol Castle, 1125*, c.1917-18, oil on canvas

Young Bristolians happily invade the grassy mounds of Castle Park, just east of High Street, from the first sunny days of spring. Few realise that within living memory this was the dense heart of the city, and home to its smartest shops and cinemas. The eponymous castle was begun just after the Norman Conquest, and hugely strengthened with a massive stone keep in the early 12th century. It was palace and prison to several medieval kings and princes, but saw no major battle and was semi-ruinous by the 16th century. It acted as a focus for Royalist ambition during the Civil War and Cromwell ordered its demolition in 1655. Fragments of the castle walls, turrets and some non-defensive buildings survived, built into the fabric of the timber-framed houses which shortly covered the site (p.22). Most of these houses soon became shops, especially in and around Castle Street.

Intensive bombing in 1940-1 destroyed much of the area, leaving the gaunt ruined churches of St Peter and St Mary le Port as memorials to the destruction.

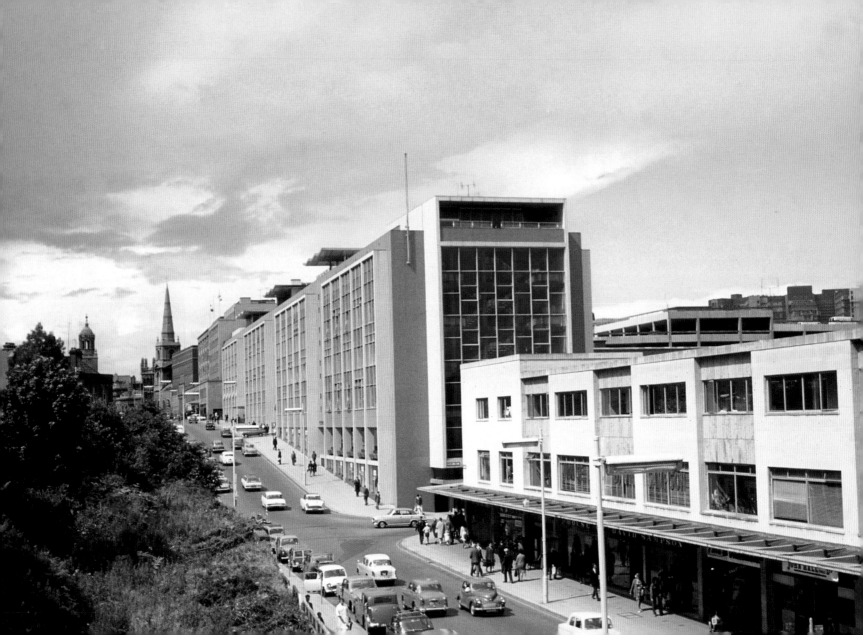

(facing) *Fairfax House and Newgate from Broad Weir,* c.1962-4, photograph

The story of shopping in Bristol is one of constant reinvention. The monolithic Modernist block of Fairfax House was the main Co-operative store, replacing one on Castle Street. Opened in 1961, it was among the largest and most up-to-date stores in Bristol, with a bridge to a multi-storey car park behind. Fairfax House was itself replaced in 1988-9 by the Galleries shopping centre. Across the park, two vaulted rooms associated with medieval Royal lodgings survived the 17th-century demolition and the bombing too; they now stand alone near the east end of the park as witness to a former grandeur. In 1938 one was a tobacconist and sweet shop (right), selling Gold Flake tobacco, Star and Player's cigarettes, with jars of Pascall's Butter Almonds, Acid Lollies and Fry's Chocolate Creams. A woman reaches for a box of Rowntree's chocolates, proving the truth of their advert – she does prefer them!

(right) *Tobacconist and sweet shop inside the castle vaults,* 1938, photograph

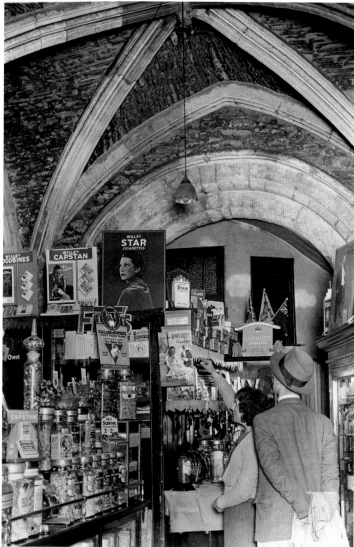

(below) *The junction of Castle Street and Peter Street,* **c.1890, photograph**

Seventeenth-century jettied and gabled houses cluster around the junction of Castle Street, to the right, and Peter Street, left. In the centre, Little Peter Street slopes down towards Newgate, and the gables of the Cat and Wheel public house. Beavis's shellfish shop, a Victorian institution, has canvas blinds drawn against the afternoon sun.

Altogether smarter is the 1830s clientele at the Upper Arcade in Broadmead (right), This and Lower Arcade were built together in matching style in 1824-5. Modelled after London's Burlington Arcade, they brought a new exclusivity to shopping in the city.

Upper Arcade was gutted in Bristol's blitz.

(right) *Interior of the Upper St James's Arcade,* **c.1830, engraving**

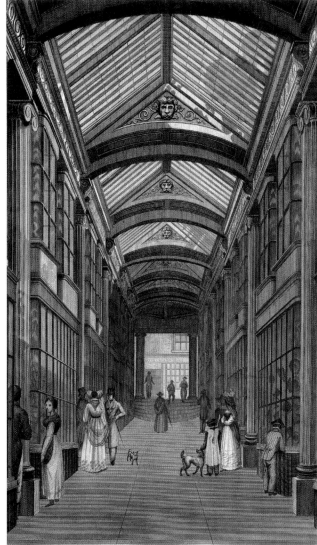

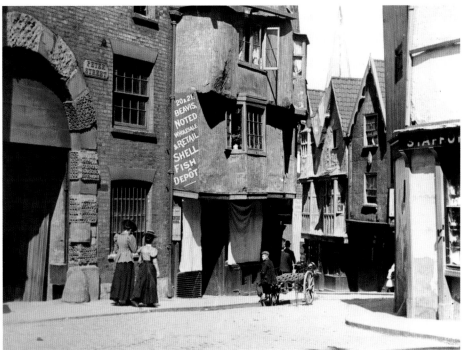

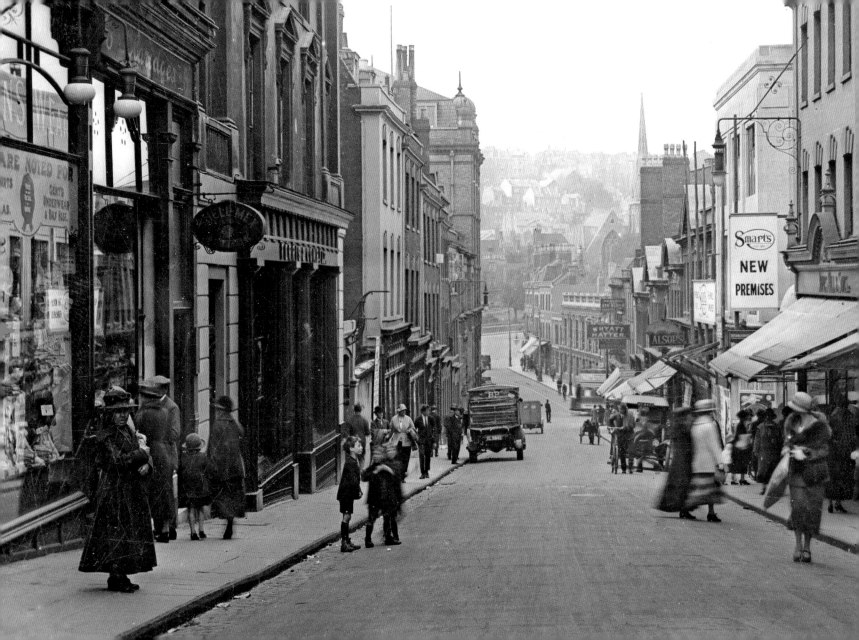

(facing) *Union Street,* **c.1925, photograph**

Union Street in the mid-1920s was filled with smart middle-class businesses such as Smart's and Alsop's furniture shops. Opposite, Ferris the Druggist had traded since the 1830s from attractive Greek Revival premises with fluted columns, selling their own-brand 'Thymol' antiseptic soap. The years from 1880 to 1930 roughly mark the point when shopkeepers ceased making and packaging products on the premises. Bristol had been responsible for the invention of numerous household products; Brolac paints and self-raising flour were first made in Broadmead. At Fry's factory (the towering building at the bottom of Union Street on the left), the world's first solid bar of chocolate was made in 1847. Broadmead was also famous for its nonconformist chapels. Among the earliest, Broadmead Baptist church is seen at the bottom of Union Street, on the site it has occupied since 1671. The world's first purpose-built Methodist meeting house is Wesley's New Room (right), restored to perfect Georgian reserve and simplicity in 1929-32. Bristol continues to attract free-thinkers and nonconformists of all beliefs (below).

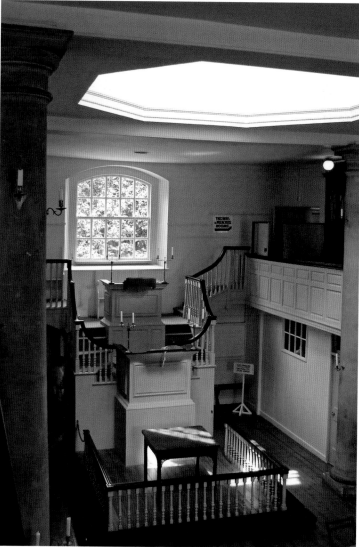

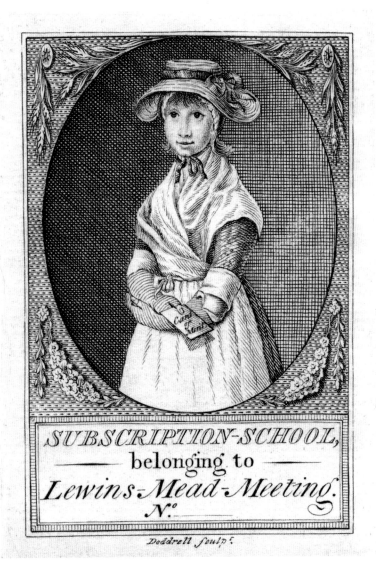

SUBSCRIPTION-SCHOOL,
— belonging to —
Lewins-Mead-Meeting.
Nº

Doddrell sculpt.

(left) *Membership card for Lewin's Mead Meeting House Subscription School*, c.1830, engraving.

Nonconformity and manufacturing wealth grew not as twins but as triplets with their sister, philanthropy. Bristol's industrialists were often Quakers (the Harfords, in banking; the Frys, in chocolate; the Champions, in brass and much else), or Congregationalists (the Willses, in tobacco manufacturing). They gave generously for the relief of poverty and the spread of faith and education. Hospitals, parks, museums, libraries, concert halls and the University of Bristol all owe their existence to these families. The Unitarian Meeting at Lewin's Mead was favoured by intellectuals and professionals with a natural interest in education. This girl holding her Card of Merit for Lewin's Mead Subscription School (left) looks as pretty and innocent as any sitter to Hogarth or Reynolds. St Peter's Hospital (above) was a spectacular merchant's house converted in the 1690s to an early Work House for the relief of those in extreme want. The building was destroyed in the wartime bombing of 24 November 1940.

(above) *St Peter's Hospital, Castle Park,* c.1890, photograph
(facing) *The Royal Hospital for Children, Upper Maudlin Street,* 2008, photograph

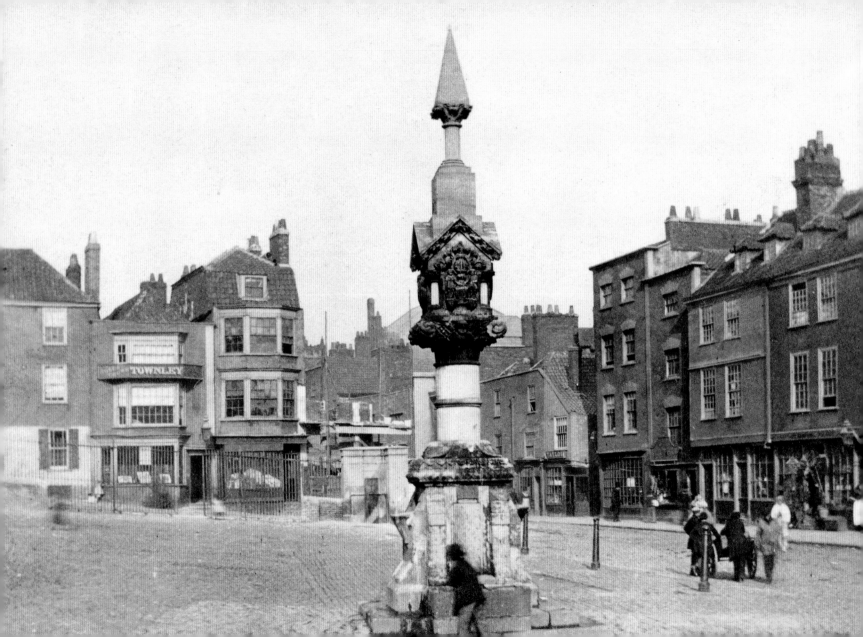

Just north of Broadmead lies St James's church (founded 1129) (right), among the oldest standing buildings in Bristol. Between St James and Broadmead were the open space known as Haymarket and the adjacent street called Horsefair; their names tell of the uses to which St James's churchyard was put in the post-medieval centuries. Here, too, the annual St James's Fair was held. Its equivalent today would comprise a heady mix of Oxford Street sale, open-air market, casino and funfair filled with shysters, pickpockets and prostitutes. It was finally abolished in 1838. In the mid-1950s when the Haymarket was obliterated by a new Lewis's store (now Primark), 16th- or 17th-century plague pits were excavated. The crypt of St Nicholas church (below) still had a bone store or charnel house until the 1970s.

(below) *The crypt of St Nicholas church*, c.1978, photograph

Broadmead's story is chequered. It began as a medieval suburb which grew up around a Dominican Friary, now Quaker's Friars. By the 18th century it was still largely residential, but peppered with backyard workshops, inns, shops and small factories. At least six nonconformist Meeting Houses thrived here, attracting the local artisans, tradesmen and shopkeepers. The Quaker Meeting in the Friars also attracted some of the most illustrious Bristol merchants, such as the Harford and Fry families. Broadmead's mixed character was sustained until the Second World War. Patchy bomb damage was outweighed by pressure from the Corporation to move the city's main shopping here from the obliterated Castle Street district. By 1960 their dream was complete, with three-storey concrete shops radiating from the crossing point of Broadmead and Merchant Street. The wasteland to the east was transformed by the Cabot Circus extension to Broadmead, built in 2005-8. It provided 95,000 square metres of shops and eating places, with a new cinema. The circus-like hub under a light steel and glass dome overlooked by galleries and cafe tables has become a popular meeting place. Already it has witnessed several flashmob events, including a performance of Hey, Big Spender by 400 singers.

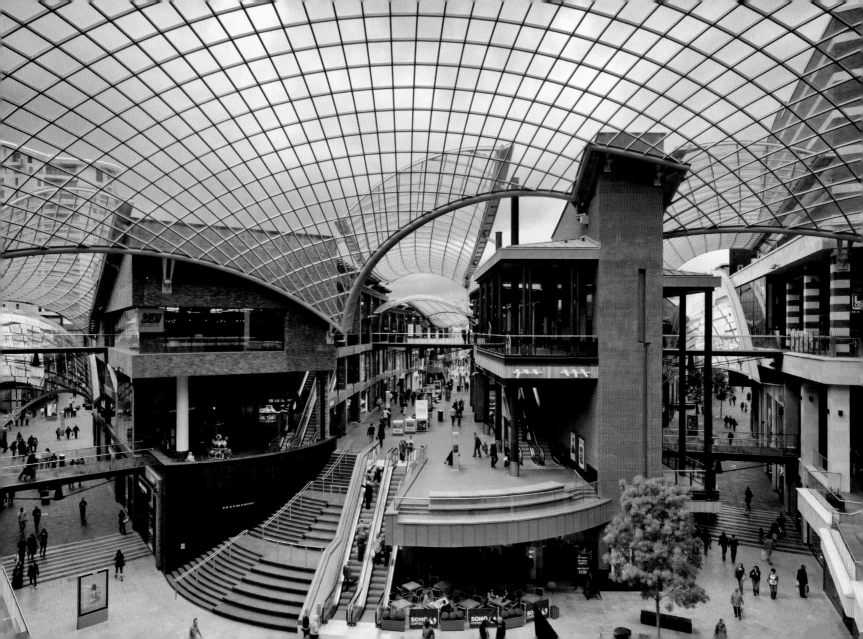

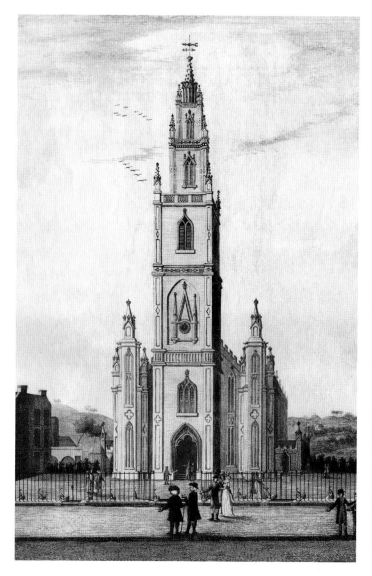

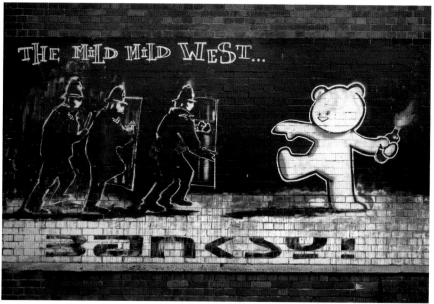

(left) *The newly constructed St Paul's church, Portland Square, Bristol,* c.1795, engraving

North of Broadmead and east of St James's church is the district of St Paul's. The gothic 'wedding cake' spire of St Paul's church (1789-94) is its major landmark. It was the centrepiece of a fashionable new suburb, a venture begun by the vestry of St James's church to house the expanding middle class. St Paul's western boundary is Stokes Croft, the start of the road from Bristol towards Gloucester. The area begins where the road runs beneath a symbolic wall of offices at St James's Barton roundabout (facing). Its quirky and distinctive identity perhaps stems from its history as a place outside the walls; in recent years it has increasingly become the home to alternative approaches, street art and philosophies. The People's Republic of Stokes Croft, a social-enterprise group founded in 2009, works to draw these ideas together and promote the regeneration of culture, business and the built fabric.

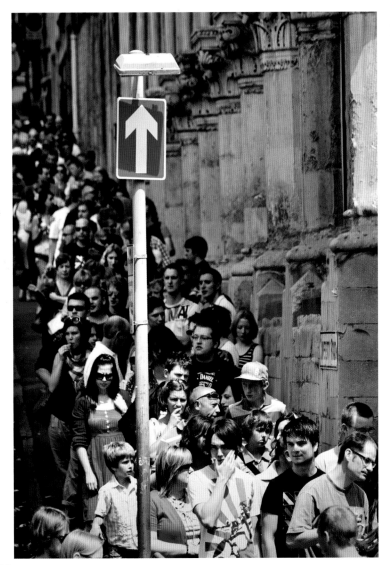

A little way north is the junction with Jamaica Street, opposite which is a pair of graffiti-adorned Victorian shops. One of Bristol's best known recent artworks is Banksy's Mild Mild West mural (p.33). Banksy began to be noticed in the late 1990s as a graffiti artist, always hiding his true identity, appearance and location. The resulting mystique was partly responsible for the growth in the desirability of his work. In 2009 he achieved a coup-de-theatre with an exhibition provocatively called Banksy v. Bristol Museum. Until two days beforehand, only the Museum director and a handful of staff were in the know. It took Bristol unawares, quickly becoming a hot ticket. A side road was closed to contain the enormous queue; almost 309,000 visitors went through the doors (left). It became the 30th most visited exhibition in the world in 2009, and visitors who had come solely to see it spent over £10 million.

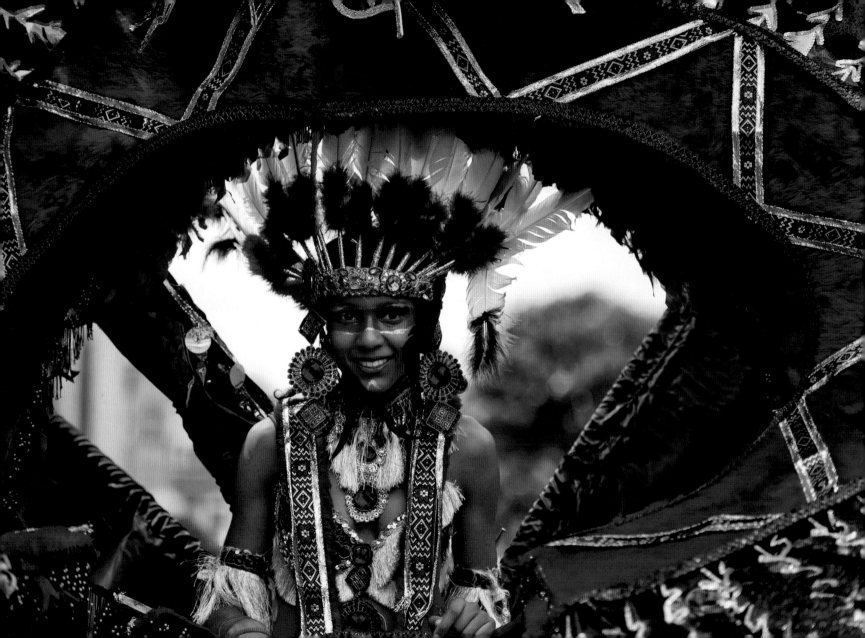

The idea that the black population of St Paul's directly stems from the days of slavery has been disproven. In 1945 St Paul's was a run-down area of factories and cheap rented housing, mostly white and working class. From the time of the Empire Windrush it was populated by Caribbean and other immigrants, and St Paul's developed a new identity despite abuse and discrimination. Since the riots of 1981, it has been transformed by community regeneration and the restoration of its Georgian squares. While social problems are not eradicated, a confident new cultural identity has been forged. A major symbol of this is St Paul's Carnival, which began in 1967. It attracts around 80,000 people and features family events, food stalls, poetry and artists as well as the carnival procession, live music and circus performers. St Paul's church has found new life after twenty years of decay. It was restored and occupied in 2005 by Circomedia, called the RADA of circus training (below). The grand old church (right) is admirably suited to this role, wearing its new garb lightly.

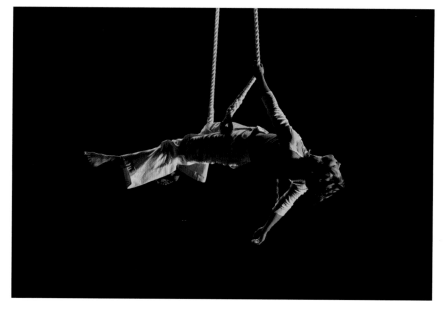

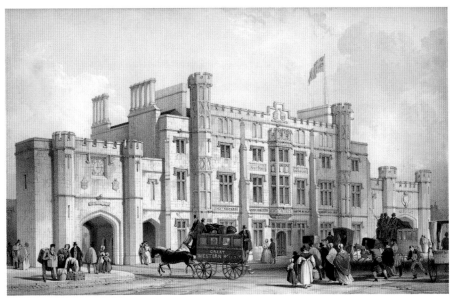

(above) S.C. Jones, *Bristol Terminus of the Great Western Railway*, c.1841, lithograph

Temple Meads was originally marshy meadowland on the River Avon south of Bristol. It lay in Somerset, beyond the wall built in the mid-13th century to protect the districts of Temple and Redcliffe. The road from Bath arrived here at Temple Gate, but apart from some inns and houses clustered around the gate, Temple Meads remained unbuilt in the early 19th century. It was, however, no more than half a mile from Bristol Bridge, the quays and the main financial streets, a fact which was uppermost in its choice for a new railway terminus. The Great Western Railway Co. was incorporated in 1835 to open a line to London. The line to Bath opened in 1840; London trains arrived in June 1841. It was undoubtedly a feat of engineering, though the fawning dedication to this view of the office building, proclaiming it 'unquestionably the greatest public work ever executed in ancient or modern times', seems rather overstated.

(facing) *Aerial view of Temple Meads station*, 26 January 1978, photograph

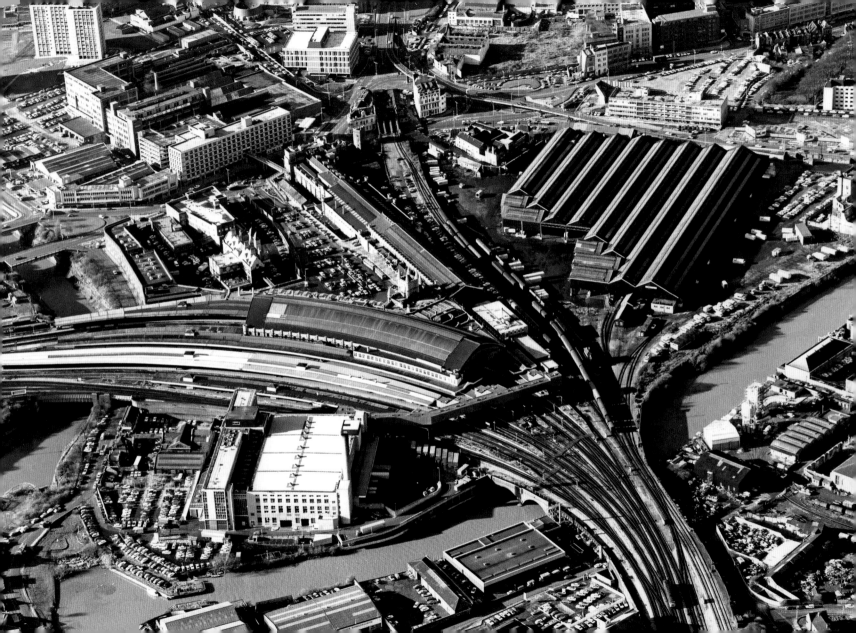

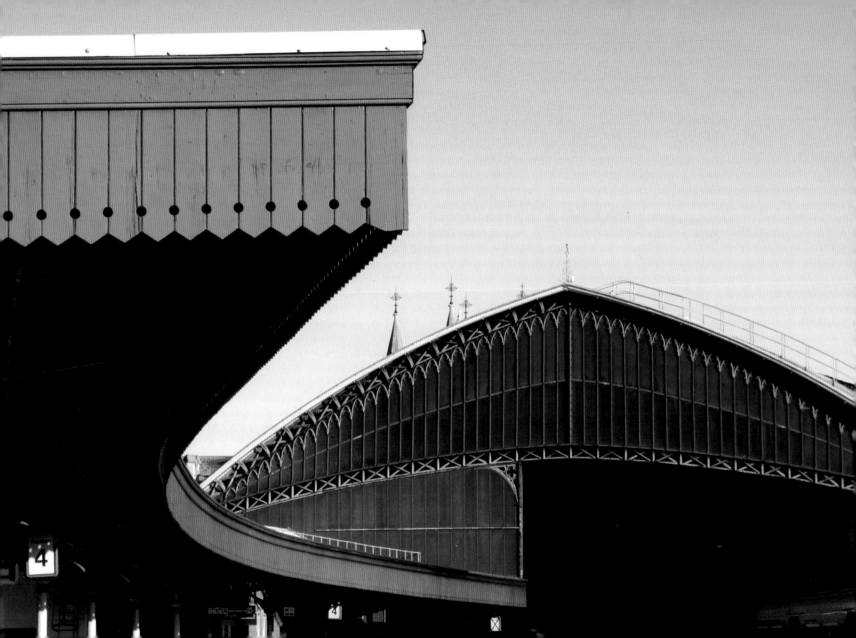

(below) *Temple Way flyover across Victoria Street, seen from the end of Redcliffe Way, c.1968, photograph*

The first terminus, designed by the company's young Chief Engineer Isambard Kingdom Brunel, consisted of a long narrow shed running straight ahead from the point where the main line arrived on its viaduct crossing the harbour. The Tudor Revival company offices sat at the end of the platforms, facing the street. By the 1870s this was inadequate; higher passenger numbers and junctions with other railways necessitated a new main train shed, curving away to the south of the old lines. Today's ticket office and platforms occupy this building, with its characteristic iron-framed arched roof designed by the engineer Francis Fox.

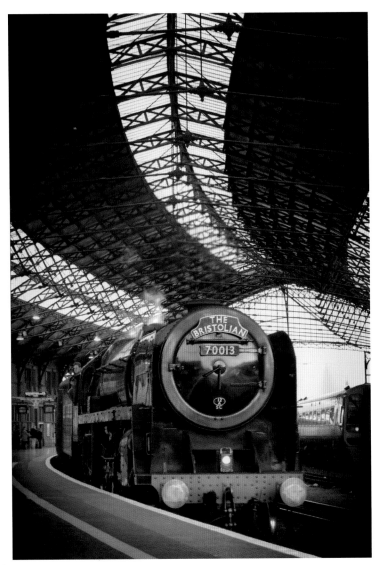

(facing) John Cooke Bourne (1814-96), *Bristol Station*, 1846, lithograph

Isambard Kingdom Brunel is now the most celebrated 19th-century figure associated with Bristol through the railway, his ships (p.62-7) and Clifton Suspension Bridge (p.102-6). His biggest challenge at Temple Meads was the design of the handsome mock-hammerbeam roof of the train shed, which proved unstable. Railway termini being a new building type, Brunel decided on fixed arrival and departure platforms to simplify the planning of the building. However, arriving trains had to be moved sideways on a complicated set of lifts beneath the tracks to set them onto the departure platform – an idea soon abandoned in favour of moving the passengers! Nevertheless, the Great Western Railway transformed Bristol, speeding up businesses communication and sweeping away its traditional insularity. Time was standardised in 1852 on Greenwich Mean Time, although the clock on the Exchange still has two minute hands, one for London time, the other showing Bristol time, about 11 minutes ahead.

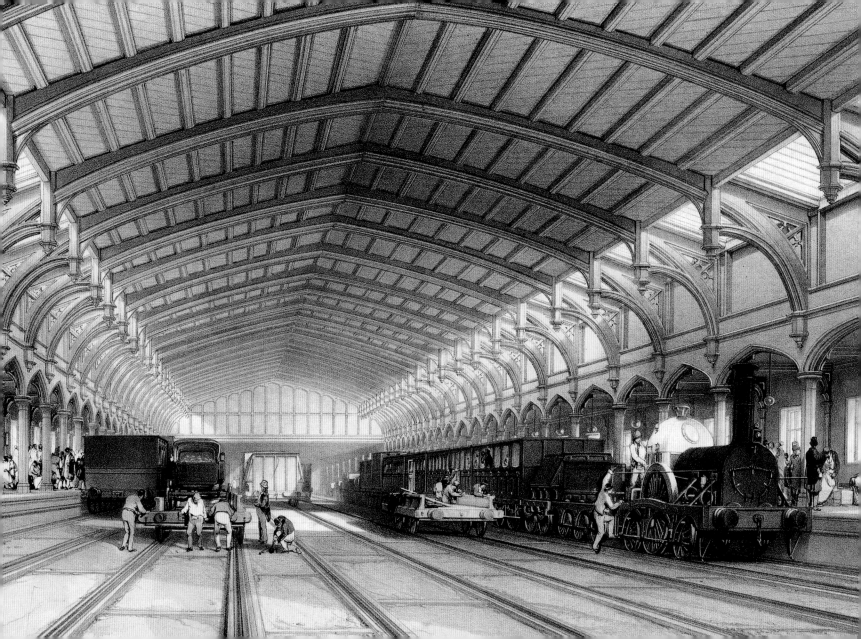

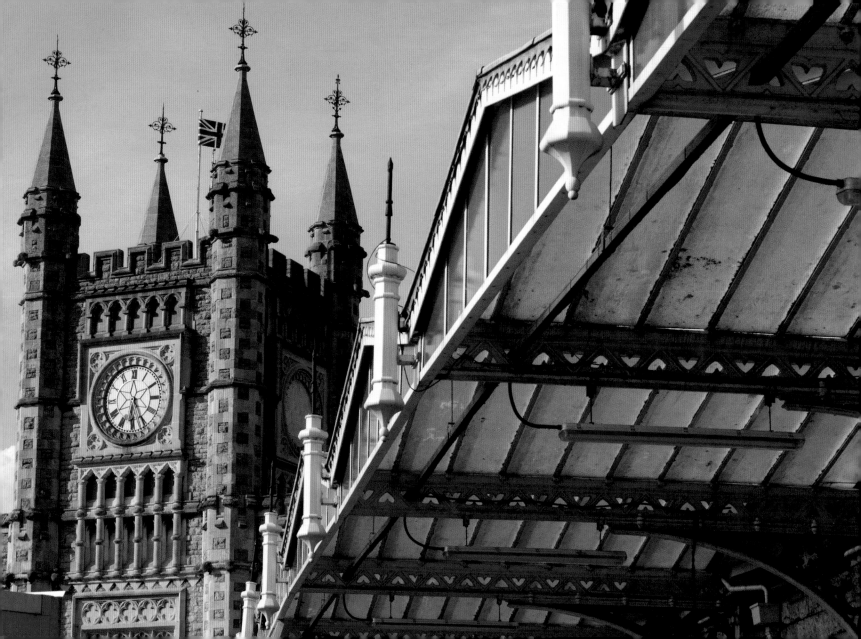

(right) *Temple Church interior from the chancel before the bombing, c.1910, photograph*

Temple earned its name from the fact that the district was owned by the Knights Templar. They built an oval church here for themselves in about 1150. It was replaced around 1312 by a parish church of more conventional rectangular form. This was bombed in 1940; the attractive ruin with its dramatically leaning tower sits in a tree-lined churchyard off Victoria Street.

Temple church was home to the medieval Weavers' Guild, a reminder that Bristol's great wealth from the 12th century onward was founded on exporting raw wool, and later woollen cloth. Temple was the main centre of the weaving and dyeing trades, and the occasional timber-framed houses among the office blocks is evidence of the antiquity of these streets. The cloth made here in the 1400s was in high demand from the cloth halls of Flanders to the mercantile palaces of Renaissance Venice and Florence.

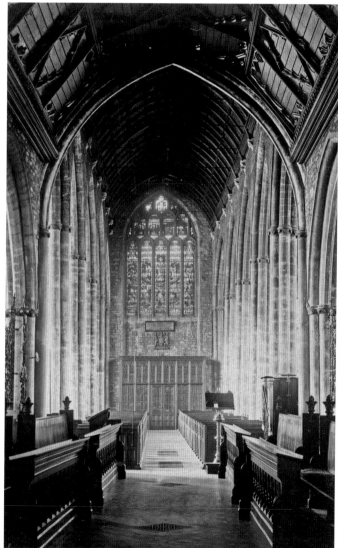

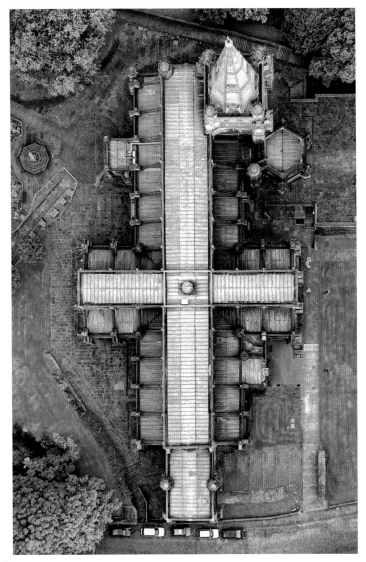

Redcliffe, like Temple, sits south of a deep curve in the River Avon. It was an important trading suburb on the south-western road out of Bristol. Its name derives from the red sandstone bluff which forms low cliffs near the Ostrich Inn on the harbour. Dominating all around is the church of St Mary Redcliffe, reckoned the grandest and most ambitious parish church in England; indeed its dimensions are cathedral-like. The spire is 292ft high (89m), and the interior is 240ft (73m) from west to east. It was by tradition the sailors' church. The north porch contains a tiny chapel, no more than a recess a couple of feet deep separated from the interior of the porch by a stone screen. Here it is said sailors could offer prayers for a safe return if they had to sail at night when the main church was shut.

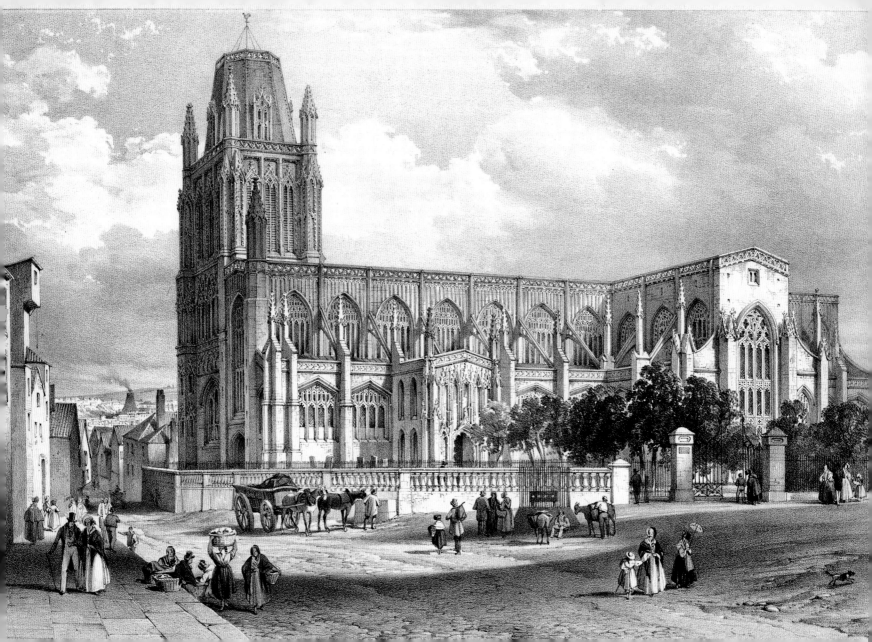

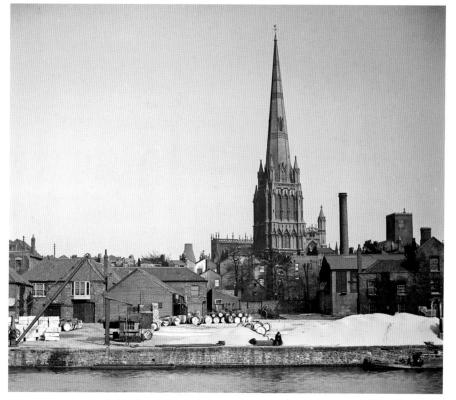

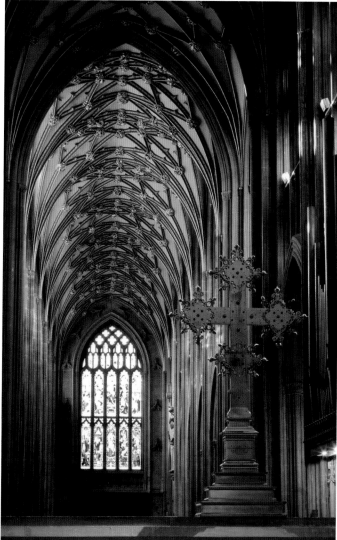

(facing) S.C. Jones, *St Mary Redcliffe,* **c.1840, lithograph**

The spire of St Mary Redcliffe was struck by lightning in 1446; it remained as a stump until the upper part was reinstated in 1870-2. Redcliffe Hill, passing the west end of the church, was a narrow and busy thoroughfare in the 19th century, being the major route to Bedminster and then the south-west of England. It was widened in 1968 with the sad loss of William Watts' Shot Tower, where the technique of making lead shot was patented in 1782.

(above) *St Mary Redcliffe, shot tower and riverside,* **c.1870s, photograph**

(facing) Fred Little, *The Llandoger Trow, King Street*, c.1911, photograph

King Street was laid out in the 1650s outside the medieval south wall, and was named after King Charles II on his Restoration in 1660. Its east end opens onto Welsh Back, and Broad Quay is close by at the west end, so trade and shipping were always predominant.

The Llandoger Trow is among the best-known of Bristol's inns, and has been a pub since at least the 18th century. Its name comes from a trow or boat which sailed to Llandoger in South Wales. The splendid timber-framed range was built in about 1664, probably as merchants' houses with storage in the cellars. The further two of the five gables were destroyed by bombing in 1941.

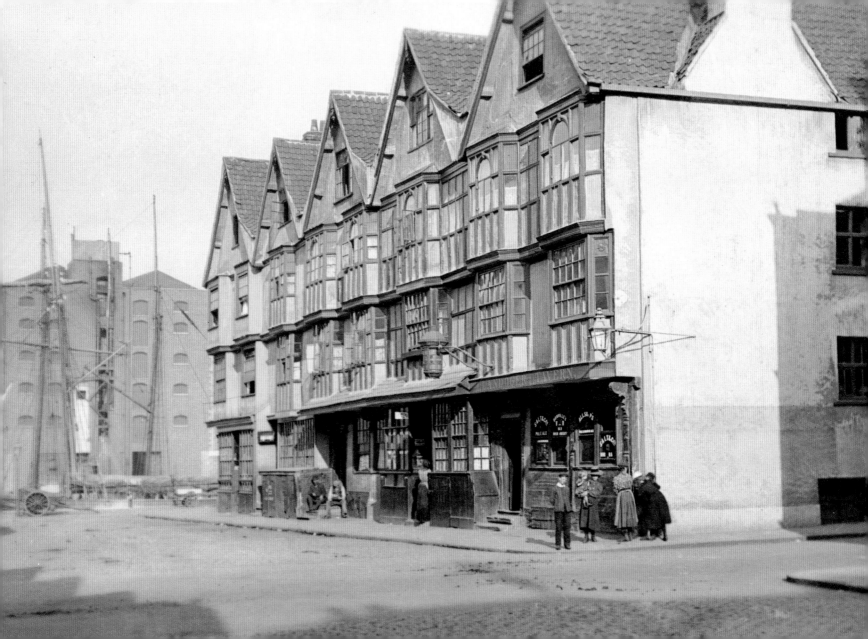

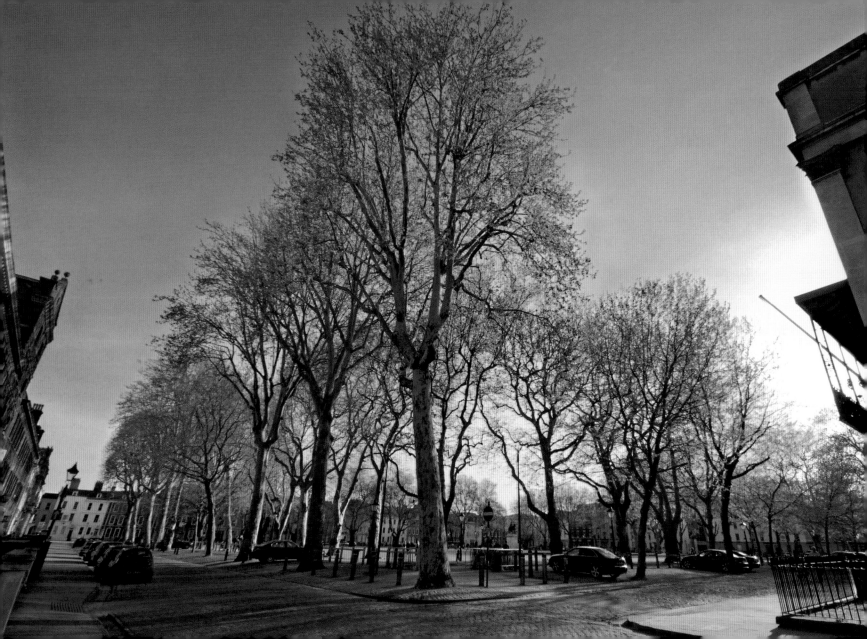

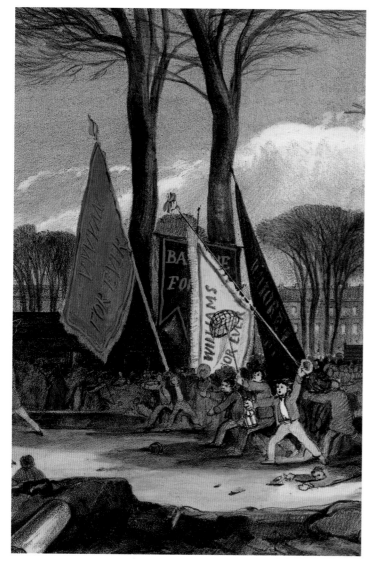

(left) J. Rowbotham & W Muller, *The First Reform Election in Queen Square*, December 1832, lithograph

Queen Square was laid out in 1699 as Bristol's first Corporation-led piece of town planning. It was intended to provide smart housing for the foremost mercantile families, but over 300 years it has assumed other dimensions of political and social significance. In 1736 the Corporation declared its Whig loyalties by placing a fine equestrian statue of King William III in the centre of the square.

In 1831 it was famously a centre of the violent rioting: perhaps as a result it was also the scene of a political rally at the Reform election of 1832. In the foreground (left) the burnt-out ruins of houses destroyed in the previous year's riots frame the scene as opposing supporters of Whig and Tory candidates rampage across the square. Despite big compensation payments to house-owners and speedy rebuilding after the riots, Queen Square could not regain its status as a smart address, and within fifty years businesses had largely taken over.

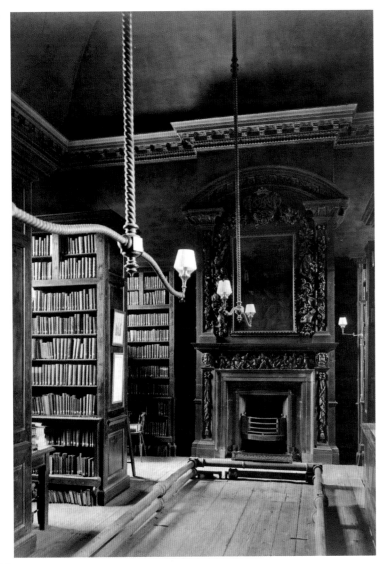

(left) *Interior of the Old Library, King Street*, c.1900, photograph

The Old Library in King Street, founded in 1613, is the third oldest public library in England. It moved to its present home (the Central Reference Library, (p.86-9)) in 1906. The splendid oak-panelled reading room was moved and reinstalled in the new building, complete with its bookcases, chimneypiece and limewood overmantel, probably by Grinling Gibbons. The library's collections are equally steeped in significance. As well as books, they include fine collections of manuscripts, prints, and photographs, many bequeathed by George Weare Braikenridge (1775–1856) from which many of the historical images in this book were drawn.

(facing) *Bristol as seen from Brandon Hill during the riots*, 30 October 1831, coloured lithograph

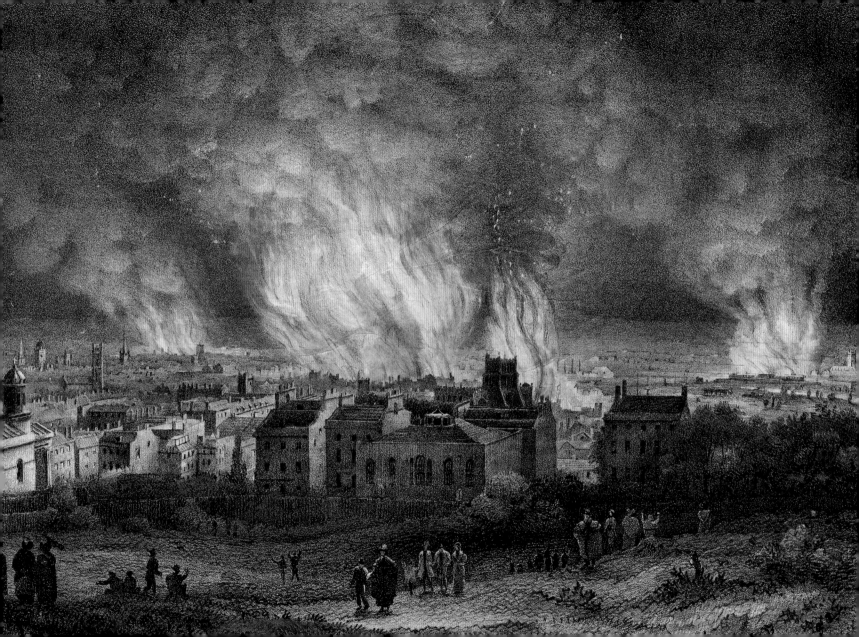

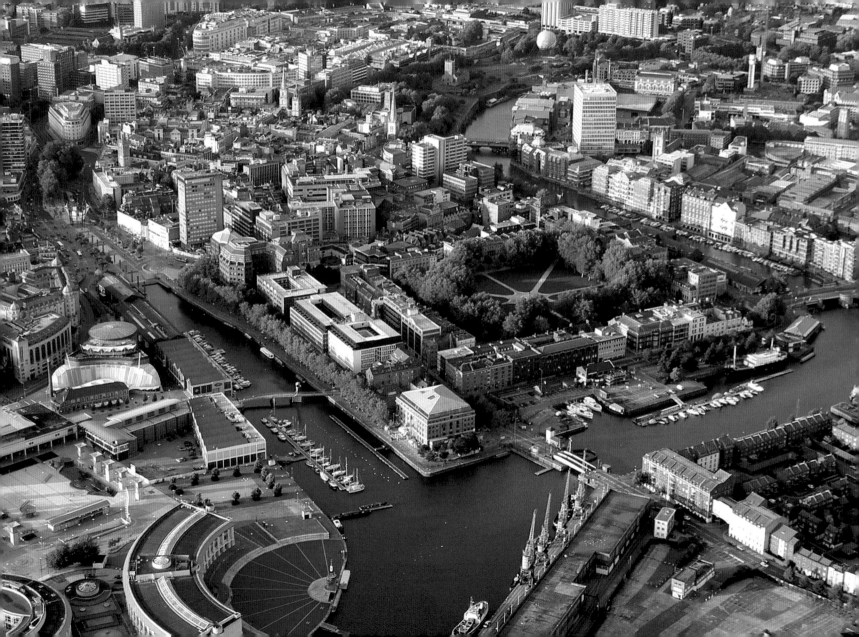

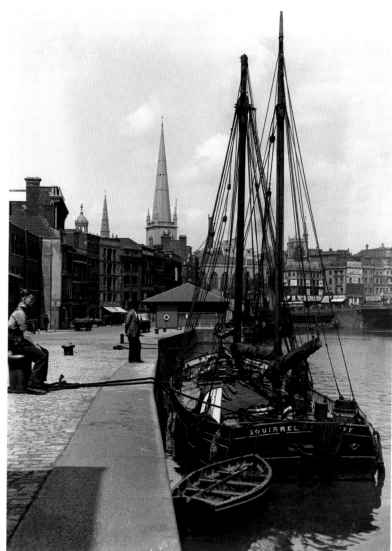

(above) *A scene at Bristol Docks,*
c.1930, photograph

In c.1240-7 Bristol men dug an
enormous new quay at St Augustine's
Reach. After this, the old eastern
arm of the harbour became the
secondary quay. Being shallower, it
suited the small vessels plying the
ports from London to Falmouth,
Watchet, Laugharne and Tenby,
across to Cork and Waterford, and
north to Liverpool, Lancaster and the
Clyde. The Severn and Wye rivers
gave access to the heart of England.
Together the coastal and inland
trades constituted as much as half of
all Bristol's business. The mellifluous
names of the boats moored at
Welsh Back serve as poem, map
and prayer. To Ireland sailed *Flora*,
Hibernia, *Lady Fitzgerald* and the
Happy Return, to Wales the *Liberty*,
Cardiff Castle, *Emlyn* and *Sprightly*.
Up the Severn went the *Hereford*,
Neptune, *Molly* and the *Stroud
Galley*, while *Hopewell*, *Industry*,
Friends Goodwill, *Sally* and the *Three
Brothers* braved the Cornish seas.

(right) *Ships on Welsh Back, looking
towards Bristol Bridge,* **c.1920,
photograph**

(facing) *HMS* Ocelot *& HMS* Taciturn *moored at Narrow Quay,* **1969, photograph**

By the early 1970s commercial traffic using the port of Bristol was declining to the point of non-existence. Avonmouth and Portishead docks dealt with the huge container vessels now coming in, and Royal Portbury Dock was already under construction. The narrow and treacherous tidal channel that runs five miles from the open sea into Bristol was no longer viable.

Bristol docks finally closed in 1974, bringing to an end 1,000 years of ship-borne trade in the city of Bristol. Although never a naval port, Bristol had a close relationship with the Royal Navy, and Hilhouse's yard built five naval frigates c.1778-85. Several vessels have borne the name HMS *Bristol*. The two Oberon-class submarines moored outside Bush House (facing), are probably paying a courtesy visit. Already, new leisure activities were becoming regular fixtures, showing the future course the harbour would take. By 1969

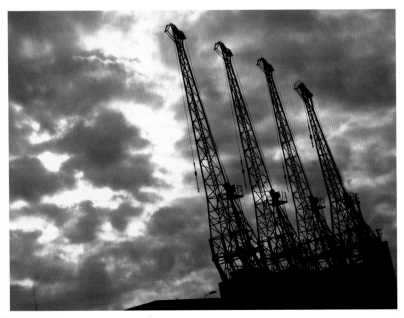

the annual power-boat races were underway, and the Bristol Water Festival began in June 1971 with a group of volunteers organising ninety small craft for a weekend gathering in St Augustine's Reach. As Bristol Harbour Festival, it celebrated its 40th anniversary in 2011, having been run by the City Council since 1978. It now attracts around a quarter of a million people and takes over the quaysides and nearby open spaces from Hotwells to Castle Park by way of Queen Square. Live music, dance, theatre, food stalls and markets jostle with the obvious water-based events for the visitor's attention.

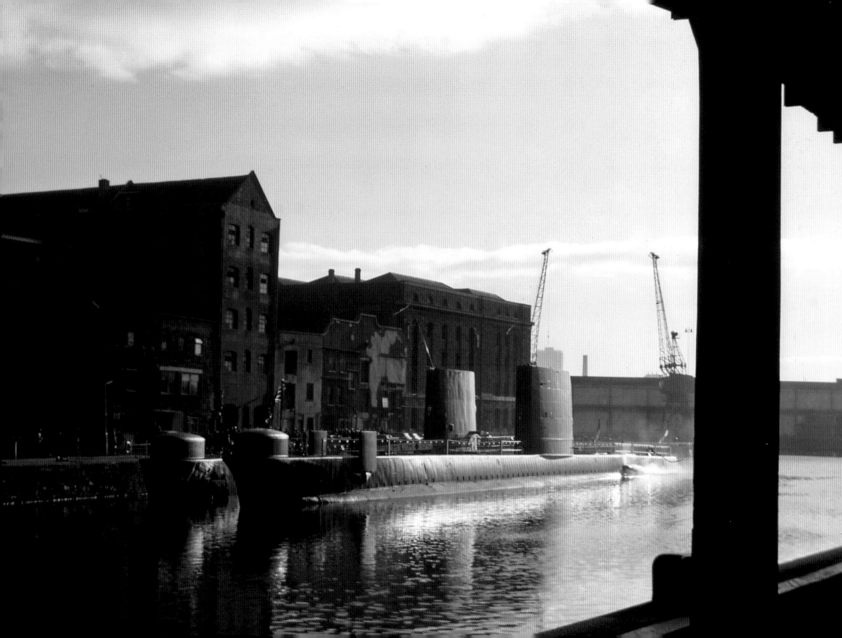

The closure of the docks left acres of derelict buildings and weed-strewn wasteland – a graveyard of gas works, timber yards, sand-dredging wharfs, coal sidings and transit sheds which were previously central to the thousand trades that made Bristol. By the mid-1970s the first big harbourside housing scheme was planned. Rownham Meads at Hotwells was completed in 1980, on a former timber wharf. Subsequently the desirability of living by the water has driven harbourside developments. This was a natural growth from the idea that the waterside could be the setting for culture and leisure. The Arnolfini gallery and the Watershed media centre established the Harbourside's claim as a cultural destination by 1980, and the transformation of Bristol Industrial Museum as M Shed fulfils it. Volunteers run its working exhibits; four electric cranes marking the heart of the harbour, the tug *John King*, the *Pyronaut* fire vessel, and the steam trains which transport tourists along the south side of the harbour on many a sunny weekend.

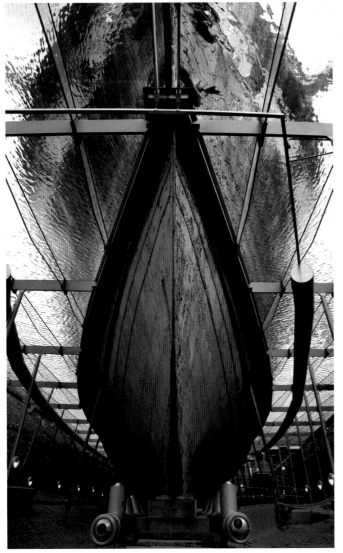

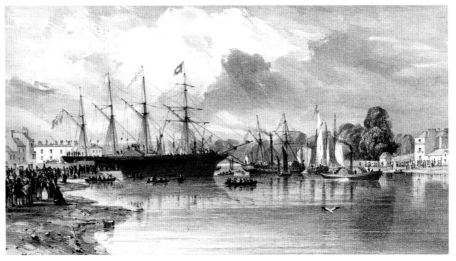

(above) J. Walter, *The Great Western Steam Ship, leaving Cumberland Basin,* 18 August 1837, lithograph

A plaque on the east wall of M Shed commemorates the building of Brunel's ss *Great Western* in a dry dock roughly beneath the museum foyer. She was begun in 1836 as the world's first transatlantic steamship. She had a wooden hull and four masts, though sail was provided only as secondary power. In July 1837 she was launched and towed to London for the steam engines to be fitted. Although she missed by hours the record of being the first steamship to complete the crossing to New York, she cut her rival's journey time from nineteen to fifteen-and-a-half days, using a fraction of the coal. In the words of the *New York Morning Herald*, she was 'black and blackguard... rakish, cool, reckless, fierce and forbidding'. The proof of Brunel's visionary genius is that he anticipated integrated travel by (his yet unbuilt) railway from London to a Bristol hotel and then by steamship to New York. It was not realised, although he built the Great Western Hotel (now Brunel House) near College Green in 1837 as its centrepiece.

(facing) *The new* Matthew *sails down the harbour with the brightly painted cottages of Clifton lining the hill in the background,* 2011, photograph

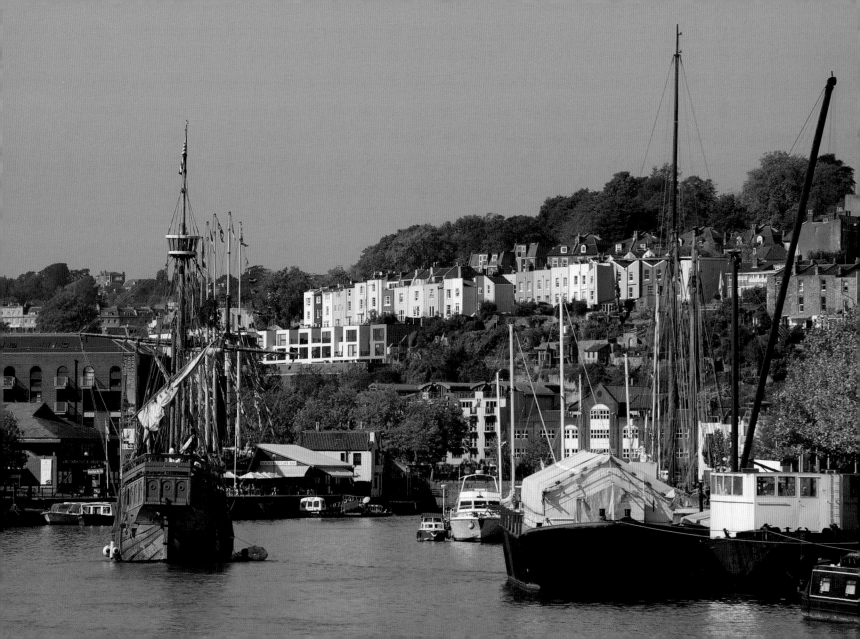

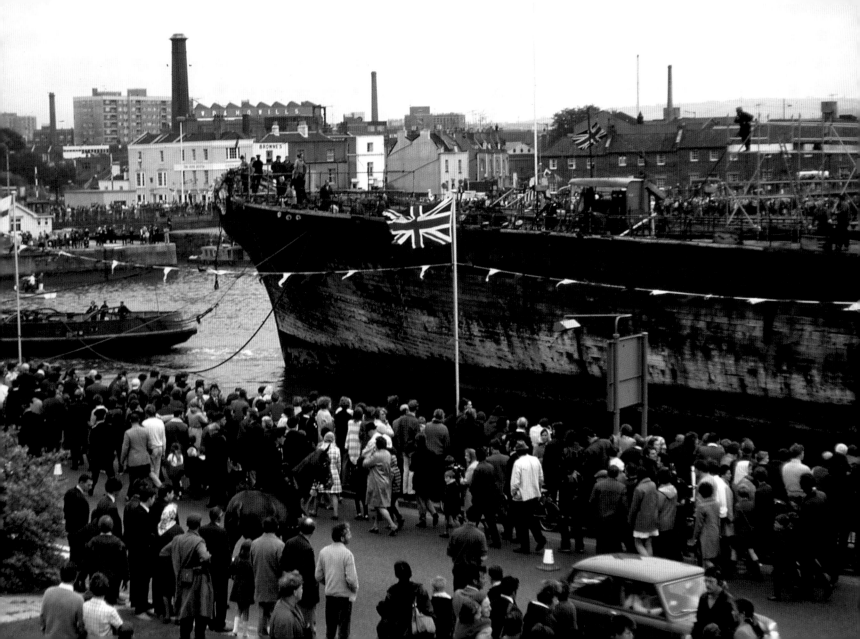

(facing) *The hulk of ss* **Great Britain** *returns triumphantly to Bristol,* July 1970, photograph

Brunel's second great ship built in Bristol, the ss *Great Britain*, ended her working life being scuttled on a beach in the Falklands Islands in 1937. In 1967 Dr Ewan Corlett, a naval architect, wrote a letter to *The Times* highlighting her fate. Partly as a result, the Brunel Society was formed in 1968 to promote the work of Brunel and to bring his great ship home. It cannot be coincidental that the first local pressure groups for architectural preservation were formed at the same time: a new sense was in the air of the importance of historical connection, of what we now called heritage. The *Great Britain* was towed triumphantly into Bristol harbour in July 1970, 127 years to the day after she had been floated out. Half the tug masters working in Bristol at the time claim to have towed her in, and none were lying; the honour was so sought after that it had to be shared. The crowds equalled those that saw her launch

as she finally came to rest back in the dock made especially for her building. It did mark a turning point for Bristol, but the vision of the harbour as a visitor attraction was not fully consolidated until the 1980s; the early years of the *Great Britain*'s time in Bristol were beset by funding difficulties and uncertain tenure of the dry dock. The most recent phase of restoration succeeded spectacularly with the creation in 2005 of a glass lid on the dry dock (p.62) in which the ship now sits, and the building of the Brunel Institute Study Centre. The museum was deservedly awarded the £100,000 Gulbenkian Prize for Museum of the Year in 2006.

Why, then, was the ss *Great Britain* so special? Like the ss *Great Western*, she was intended as a transatlantic passenger steamer. But Brunel's ambition was for an iron-hulled ship, and moreover the largest ship then built. The initial design for paddlewheels was abandoned in favour of a screw propeller, obtaining increased power efficiency and stability in the water. Despite the launching wake shown in this imaginative painting of 1919 (facing), the ship was simply floated out of her dry dock. On 19 July 1843, the ss *Great Britain* was launched in this way, with Prince Albert in attendance. Brunel's real genius was demonstrated in his ability to integrate the elements of hull design, steam engine, screw propeller and sails to create an innovative ship.

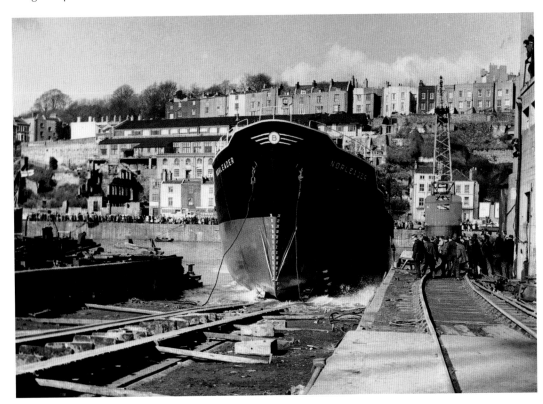

But commercial success eluded him: the ship ran aground in Ireland in 1846 and had to be sold to pay for the salvage costs. She was put to several other uses without ever fulfilling her intended role as a transatlantic passenger steamer. But her design was so far in advance of anything before, that before she ever put to sea she was synonymous with modernity and innovation, a symbol of Britain's industrial dominance as a sea-based mercantile power.

(facing) **Arthur Wilde Parsons (1854-1931),** *The Launch of the Great Western in 1837,* **c.1919, oil on canvas**

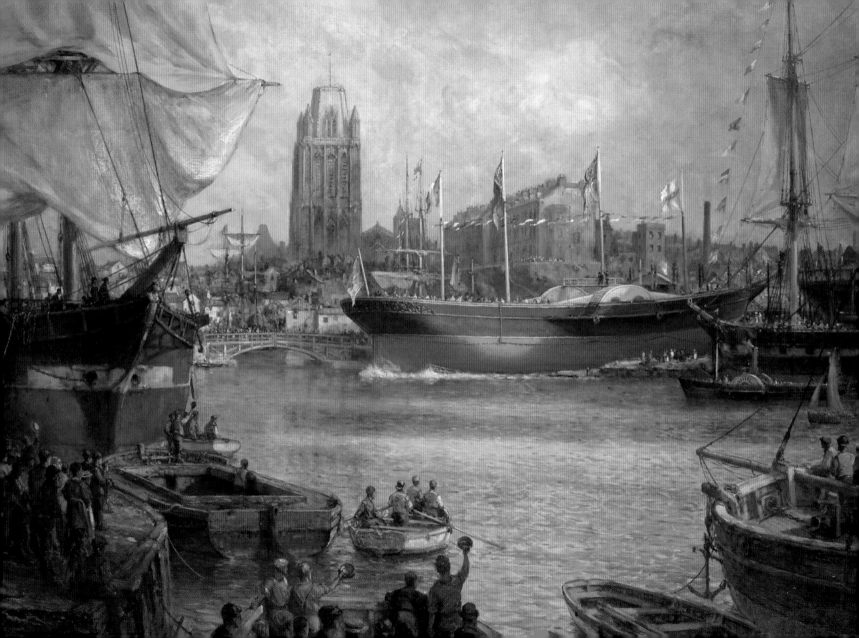

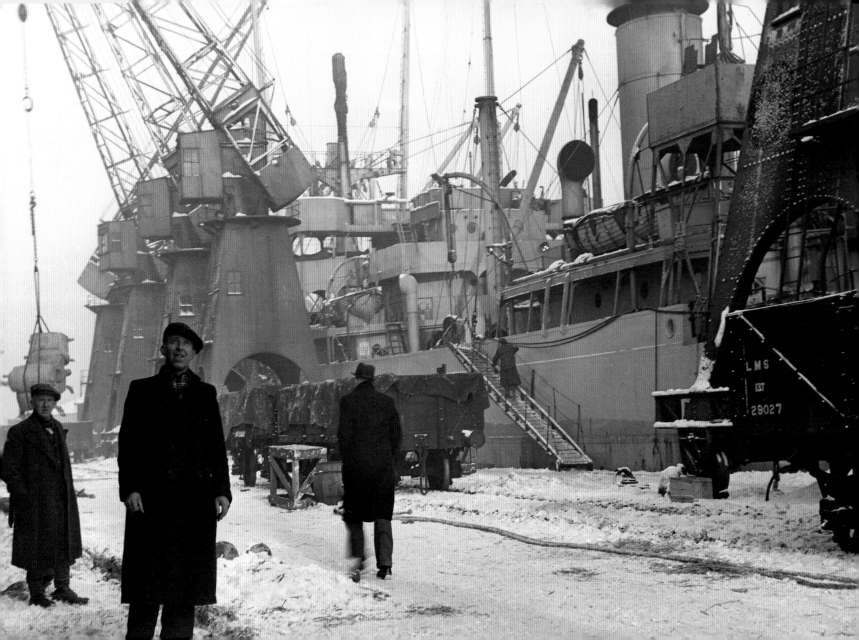

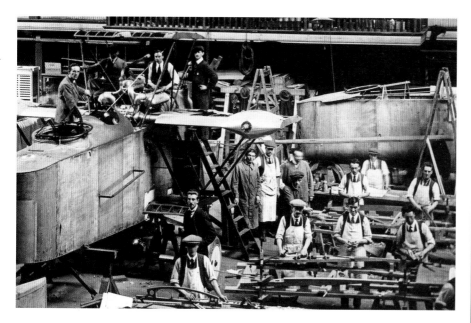

(facing) *A snowy scene at Avonmouth Docks,* mid-20th century, photograph. **(above)** *Inside George Parnall & Co., Park Row*, c.1922, photograph

By the late 20th century the docks' infrastructure became defunct. Industries closed and shipping moved to Avonmouth Docks (right), although transport remained a Bristol speciality.

Sir George White's genius, unlike Brunel's, lay in exploiting the commercial possibilities of other people's inventions.

Having exploited opportunities in trams and railways, White opened his aircraft works at Filton within seven years of the world's first powered flight. The First World War pushed others into aviation too. Parnall's, an old established shopfitters, converted their woodworking department to aircraft production, occupying the Coliseum Picture House in Park Row (p.90). The aircraft under construction in this view (above) appears to be a Parnall Possum triplane, a design which was not successful. The aviation branch of Parnall's was still in business during the Second World War.

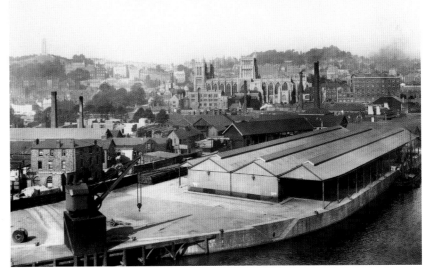

(above) *View from the Granary of Canons' Marsh*, 1901, photograph

Canons' Marsh, redesignated Harbourside in the 1990s, began life as marshy meadowland north of the River Avon. From the 12th century it belonged to the Canons of St Augustine's Abbey (now Bristol Cathedral) just to the north. By the 18th century there were scattered encroachments from rope walks, timber yards and docks, with limekilns at the western end near the road to Hotwells. Intensive industrial use arrived in the 19th century. Gas works were established near the limekilns, and timber, marble and stone yards proliferated. To service the transportation of these heavy products the GWR opened a branch line onto Canons' Marsh, with goods sheds serviced by cranes. By about 1900 it is clear that Canons' Marsh was densely occupied by industrial concerns dependent upon the combination of shipping and railways, and the transit sheds, which stored goods that moved between them. After the First World War some of these small and medium-sized concerns were cleared for the construction of seven-storey reinforced-concrete tobacco bonds.

(facing) *Inside a busy GWR goods depot, Canons' Marsh*, c.1900, photograph

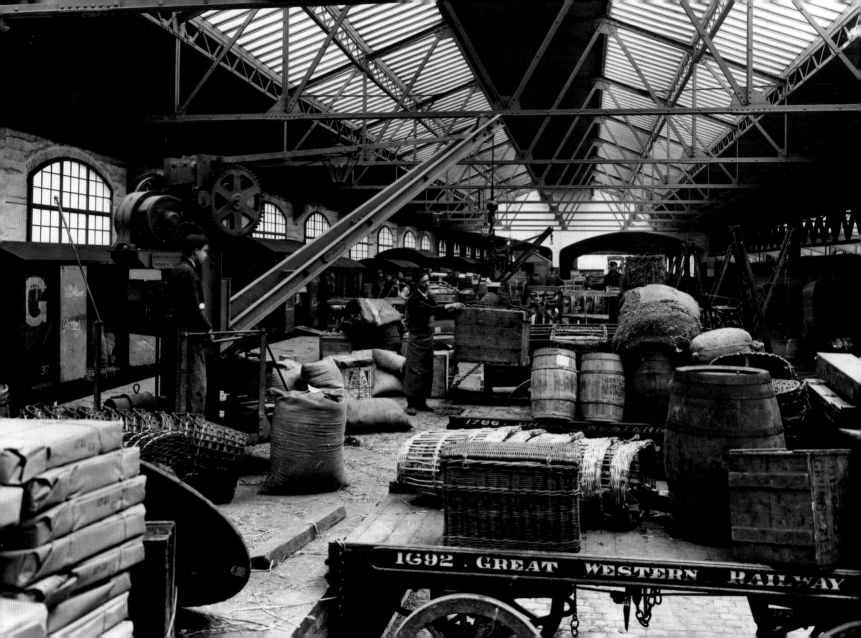

The tobacco bonds were dramatically demolished by high-explosive charges in 1988. The closure of the docks in 1974 and the removal of the Wills factories from Bedminster to Hartcliffe had left the bonded warehouses in the wrong place. Closures and dereliction made the whole of Canons' Marsh in the 1980s a forlorn and desolate area. Various regeneration schemes had been proposed since the early 1970s, but the clearances of 1988 marked the start of work. Lloyds Banking Group built their distinctive crescent-shaped offices on a prime site overlooking the waters at the meeting of the Frome and Avon branches of the harbour. The buildings and the paved amphitheatre in front were opened in 1990 and have become a local landmark. Nearby transit sheds facing St Augustine's Reach were finding temporary uses such

as the annual Bristol Wine Festival, following the reinvention of E Shed as the Watershed in 1981. The next major step in regeneration came in the late 1990s with the tourist and leisure attractions marking the Millennium. The centrepiece was the redevelopment of the surviving GWR goods shed as Explore@Bristol. Next door, new buildings were erected to house an IMAX cinema and wildlife/ecology attractions. Between these and the Lloyds Building came Millennium Square and its underground car park. The major features of the square are William Pye's polished steel water sculptures and, attached to the Explore building, the metal globe of the Planetarium raised above a shallow reflective pool (facing). The third phase of redevelopment (c.2005-11) consisted of shops, bars, restaurants and offices interspersed with blocks of flats across the west end of Canons' Marsh.

The Centre is a local Bristol term for three areas: Colston Avenue, St Augustine's Parade and Broad Quay. They form a linear thoroughfare that follows the infilled course of part of the harbour. In the 1890s a tram terminus was created here called the Tramways Centre, shortened over the years to The Centre. At the north end is Colston Avenue, surrounded by three city churches – St John on the Wall, St Stephen with its majestic four-stage Perpendicular tower, and the Greek temple front of St Mary on the Quay Roman Catholic church. The harbour was culverted here in 1892-3. The broad space created was occupied first by a temporary timber hall with broad turrets, housing the Bristol Industrial & Fine Art Exhibition. Afterwards a small park was created in the central space, surrounded by roads. It was quickly nicknamed Magpie Park for reasons still uncertain. The park was cleared away for the construction of Bristol's First World War Memorial in 1932.

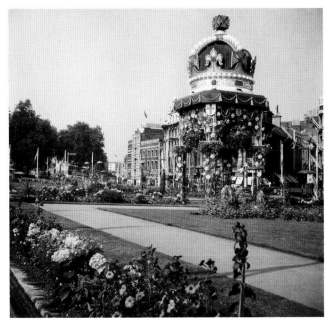

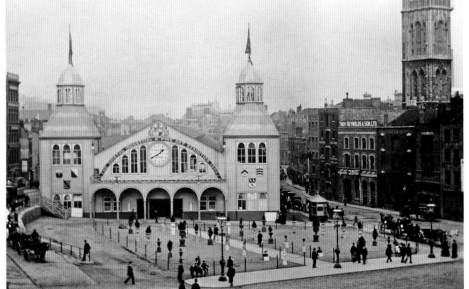

(left) Fred Little, *The Bristol Industrial & Fine Art Exhibition building, the Drawbridge*, 1893, photograph

(above) H.L. Hancock, *The gardens at The Centre, decorated for the Coronation*, 1953, Dufaycolor photograph

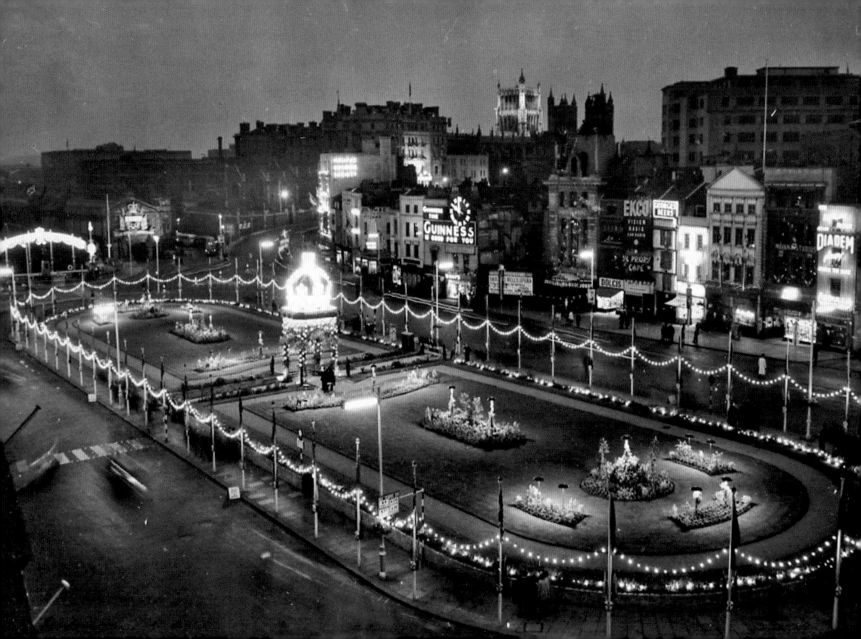

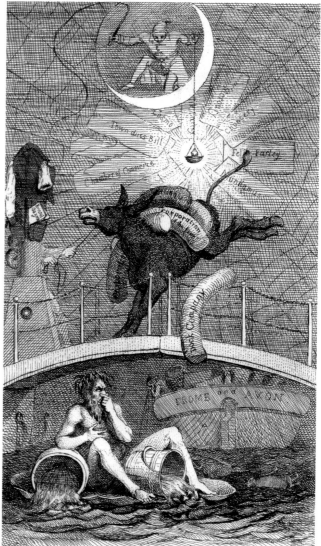

(facing) *Bristol's Garden Centre, illuminated for the Coronation,* **1953, photograph**

This satirical print (right) depicts the timber drawbridge that crossed the harbour from Clare Street to St Augustine's Parade until 1827. It defies full interpretation, but the donkey seems to represent the City of Bristol, burdened down by the Docks Co. and Poor Relief. The harbour waters are foul, floating with dead animals, obliging Neptune to hold his nose. The point here is probably an allegory of corruption, but it is a reminder that this stretch of the harbour in the 1820s was fed by the River Frome, polluted with effluents from the factories of Easton and St Philips, and with sewage from the slums of Lewin's Mead. The south end of The Centre, flanked by the Hippodrome theatre and pubs of St Augustine's Parade, looked onto open water and shipping until it was culverted over in 1937-9. The gardens laid out here formed an elongated roundabout, here (facing) decorated for the Coronation of 1953.

(right) *A donkey crossing the wooden drawbridge at the harbour,* **c.1820, satirical cartoon engraving**

(facing) *St Augustine's Parade looking south*, probably 1908, photograph

This splendidly happy view of St Augustine's Parade and the Tramways Centre was taken on a breezy summer morning, with a four-masted sailing ship in the harbour. The bunting and garlands suggest a Royal celebration, but there is nothing in the view to identify it. The date seems to be about 1907-10; a likely contender is the Royal visit of King Edward VII and Queen Alexandra on 9 July 1908. The Royal party visited to open the extension to Avonmouth Dock, where they spent the previous night on the Royal yacht, *Victoria and Albert*. On the morning of the 9th, they arrived by train at Temple Meads, rode to the Council House in Corn Street where the Lord Mayor was knighted, and then drove in open carriages to the Art Gallery for lunch. They may have just passed this point on the way, for the crowd's attention is focussed towards College Green.

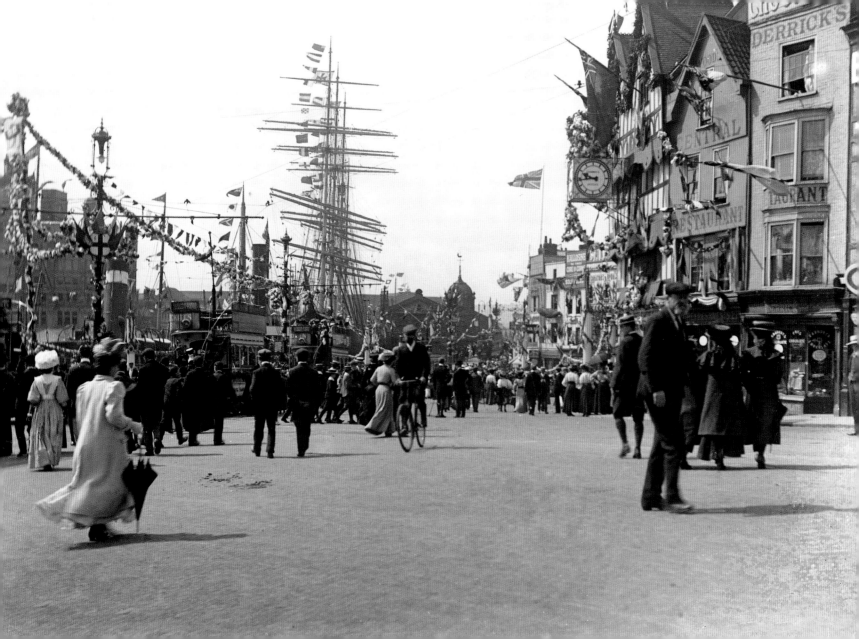

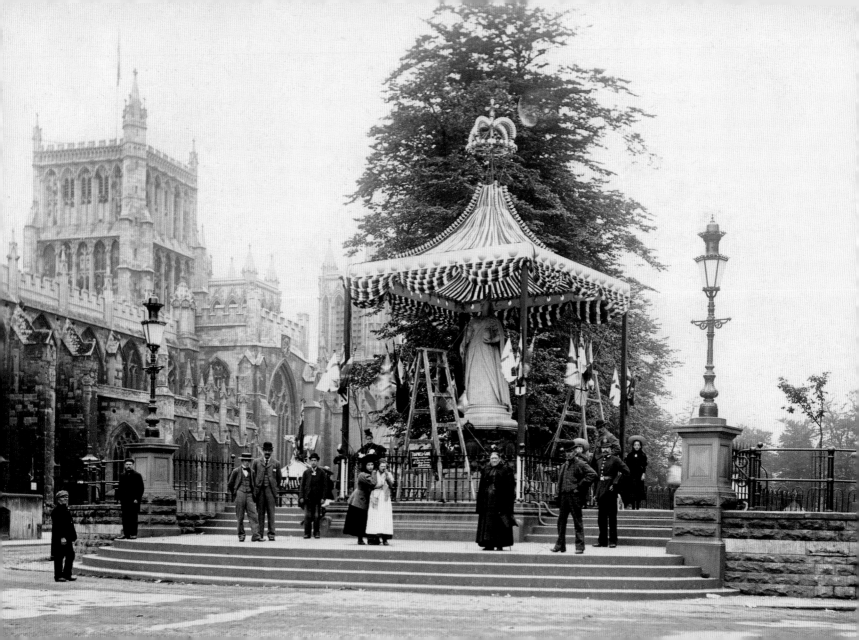

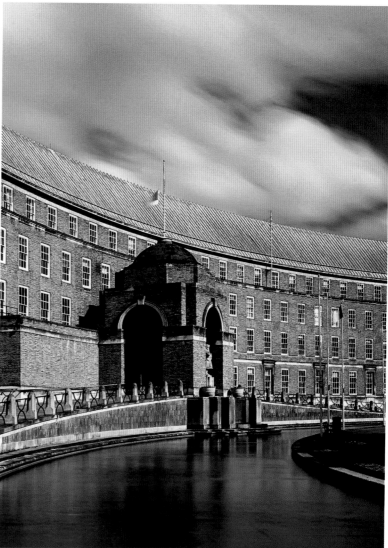

(facing) *Decorating the statue for Queen Victoria's Diamond Jubilee, College Green,* 1897, photograph
(above) *The Cathedral Hotel, Park Street,* c.1875-80, trade card

College Green is a unique open space. When Bristol was founded, this was a low hill on open ground to the west side of the city. In c.1140 it was chosen as the site of an Augustinian abbey founded by Robert Fitzharding, the 1st Lord Berkeley; the abbey became Bristol Cathedral in 1542. Its grounds included the site of College Green, which formed an open precinct in front of the abbey church. This became a raised and fenced green by the 18th century, lined with trees. The eastern apex was chosen in 1888 as the site for Boehm's regal statue of Queen Victoria (facing), shown a decade later decorated for her Diamond Jubilee. The walls and trees surrounding College Green were removed only in 1950 and the ground lowered to form the setting for the new Council House (right).

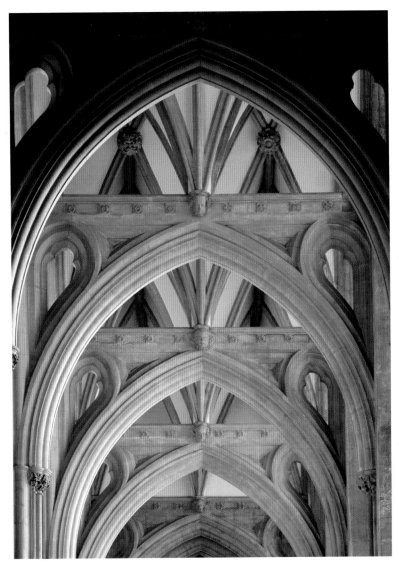

(above) *A View of the High Cross and Cathedral Church, from the North Side of College Green,* **c.1750s, engraving**

In the 1730s the medieval High Cross at the top of High Street had become an obstruction to traffic. It was dismantled and re-erected here on College Green at the central crossing of the paths (above). Even here it was an obstruction; one complainant remarked that the cross prevented strollers traversing this junction three-abreast. In 1764 the cross was given to Henry Hoare who moved it to Stourhead where is still stands today. At the time the print above was made, the cathedral consisted only of the east end, central tower and transepts. A previous rebuilding of the nave in the early 16th century had only reached the window sills at the abbey's dissolution in 1539, and the work was levelled for housing.

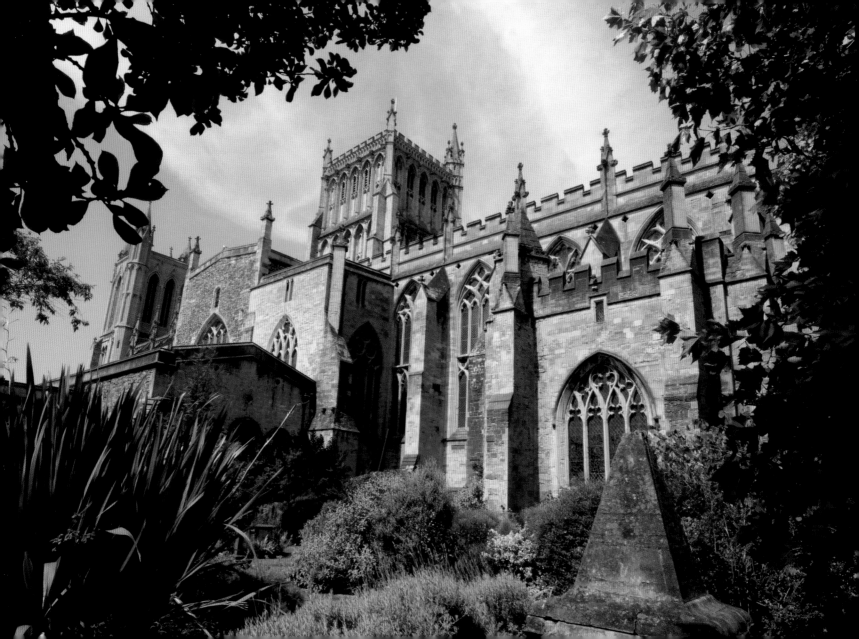

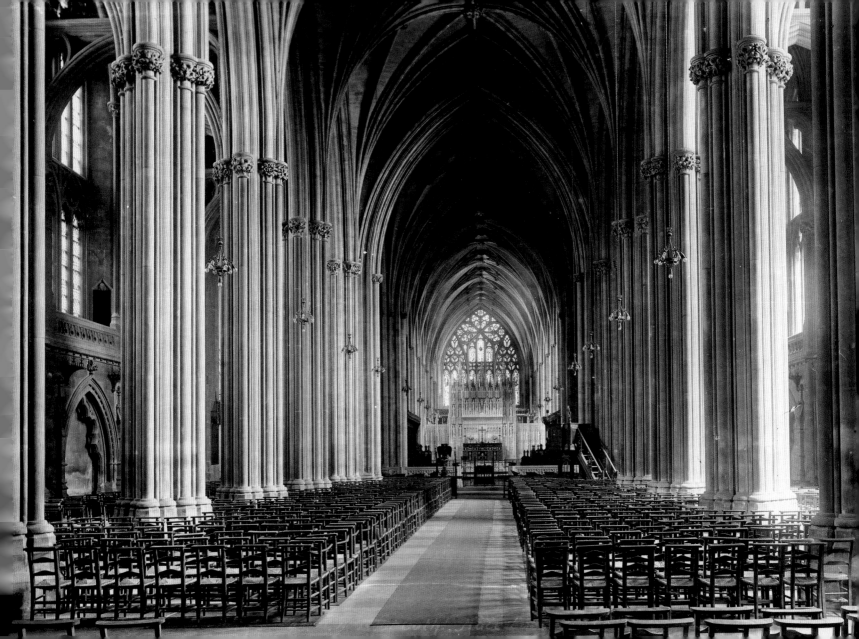

(facing) *The Cathedral Nave looking east,* **1887, photograph**

The truncated state of Bristol Cathedral caused increasing discomfiture in the light of Victorian restorations which were renewing churches everywhere. Bristol's was felt to be one of the least impressive of England's cathedrals until a new nave was started in 1867, designed by G.E. Street, one of the mightiest architects of the Gothic Revival. Street built on the 16th-century foundations which had been rediscovered in 1865; he sought to create a harmonious introduction to the east end without upstaging the medieval work. Canon J.P. Norris was the moving spirit behind the project, energetically publicising the work, recruiting support and persuading influential figures to donate funds. The Dean and Chapter were less enthusiastic. After doctrinal differences with Norris, and Street's death in 1881, the project dragged on until 1888. Despite this, the result is highly successful, and many visitors never suspect it is not medieval.

(below) *Inside the Central Reference Library,* **c.1920s, photograph**

West of the Cathedral is Deanery Road, home of Bristol Central Library since 1906. It is no coincidence that so many public libraries were built then, for they embody more than any other building type the Edwardian values of public philanthropy, reverence for the past and robust confidence in a future bolstered by self-improvement and universal education. The architect Charles Holden designed every detail of fittings and furniture; the upper Reading Room retains the original teak desks, chairs and revolving newspaper tables, still admirably suited to their purpose after 100 years. Directly opposite the west end of the library is Horizon House, the national headquarters of the Environment Agency (facing), opened in 2010. The

client's requirements were met by close working with Westmark Developments and the architects Alec French Partnership. The Environment Agency conceived the building as a model of environmental efficiency. The best available technologies, both low and high, were incorporated: harvested rainwater to flush the toilets, renewable energy is provided from ground-source heat pumps, photovoltaic and solar thermal arrays, a mixed natural and mechanical ventilation system, and sophisticated energy monitoring. The symbolic green stained-glass entrance bay was created by the artist Kate Maestri. It was voted the greenest office building in the UK in 2010.

(facing) *The innovative Horizon House, Westmark Developments, Deanery Road,* **2011, photograph**

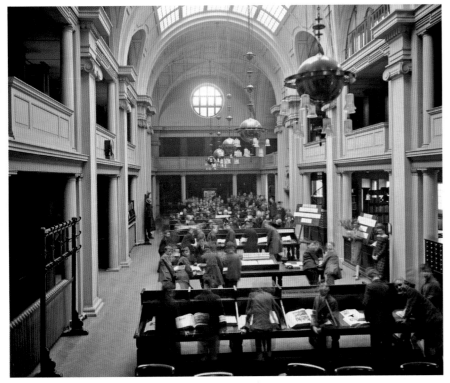

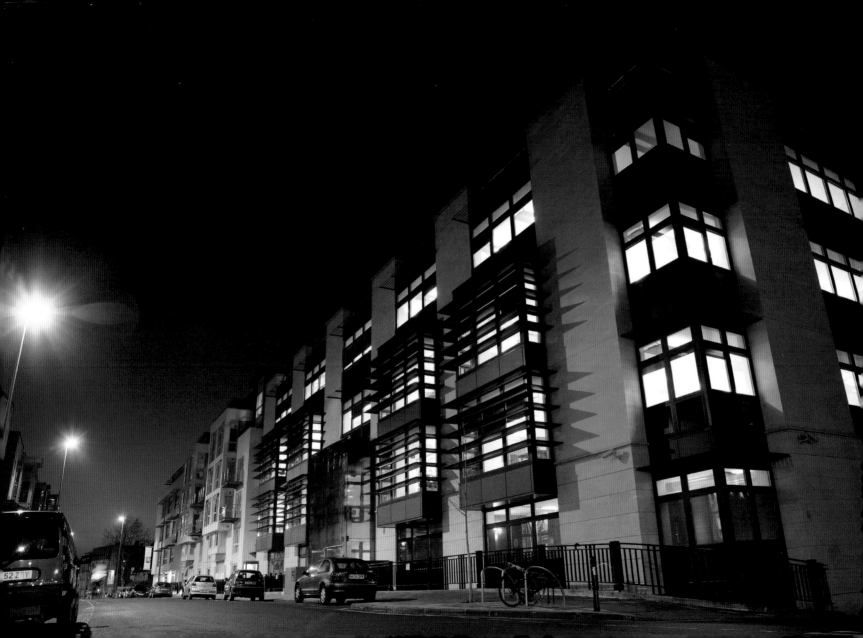

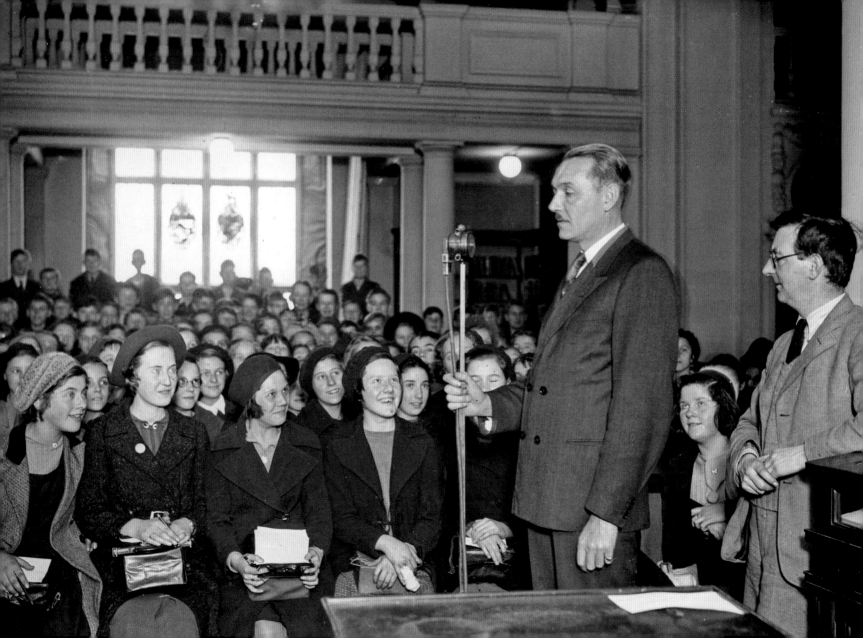

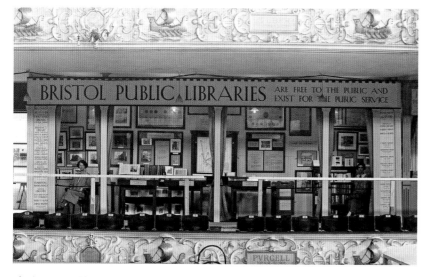

(facing) *Weekly half-hour talks to children at Bristol Reference Library, c.1940, photograph*
(above) *Bristol Public Library stand at the 'Bristol First' exhibition, Colston Hall, c.1920s, photograph*

The Central Library has always been about much more than books alone. From at least the mid-19th century it has provided a programme of public events such as exhibitions and lectures. The less-than-snappy title of an exhibition at Colston Hall proclaims 'Bristol Public Libraries are free to the public and exist for the public service'. The hall appears in its Edwardian dress (above) destroyed by fire in 1945, with friezes of florid strapwork and ships adorning the balcony fronts. Weekly half-hour talks for children were a feature of the wartime events programme provided at the Reference Library Reading Room. Here the speaker's deadpan expression (facing) belies the rapt adoration on the faces of his audience. Perhaps he had just outlined the breadth and extraordinary range of the historic collections of manuscripts, books and images that have been built up by Bristol Library since the 18th century.

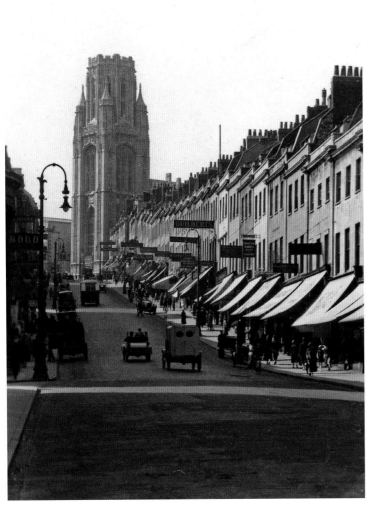

(left) *Park Street and the Wills Memorial Tower*, c.1930s, photograph
(below) *The Coliseum Picture House, Park Row*, c.1911-14, photograph

Until the 1760s College Green was backed to the north by a steep, open hillside called Bullock's Park. The lane to Clifton was Park Row, which ran north-west from the bottom of St Michael's Hill. This remained partly open until the very end of the 19th century; the Coliseum Picture House of 1910 filled one of the last open sites. Park Street and its adjuncts, Great George Street, Charlotte Street and Berkeley Square, were developed c.1760-1800. The plain Bath-stone fronted terraces were originally houses for merchants. Within 70 years of building, a significant number of houses on Park Street were converted to shops, taking advantage of the position between the smart residential areas of Clifton and College Green. Now only one original doorway survives. Park Street now offers a mixture of bars with student-oriented and smart shopping.

(facing) *Cabot Tower, Brandon Hill*, **2009, photograph**

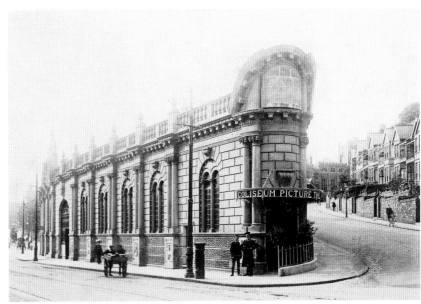

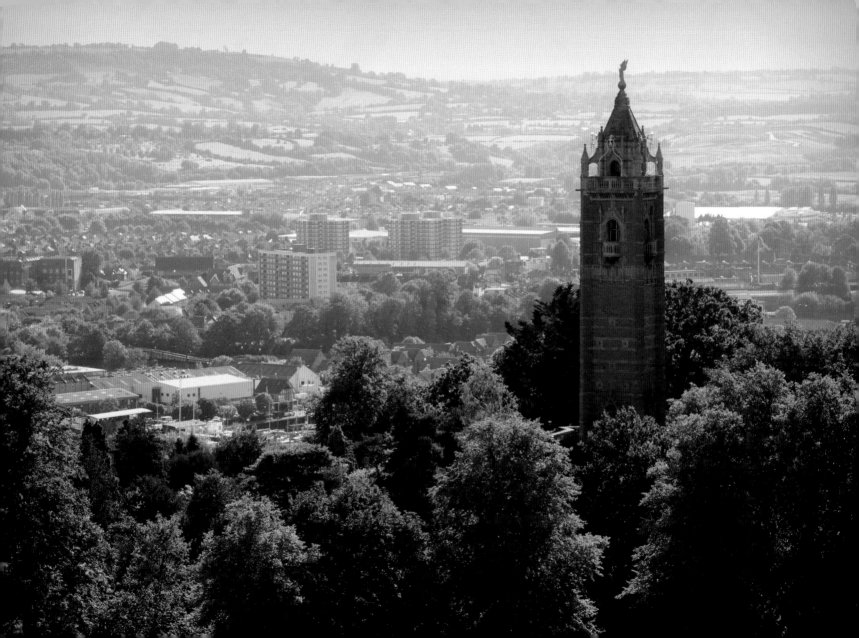

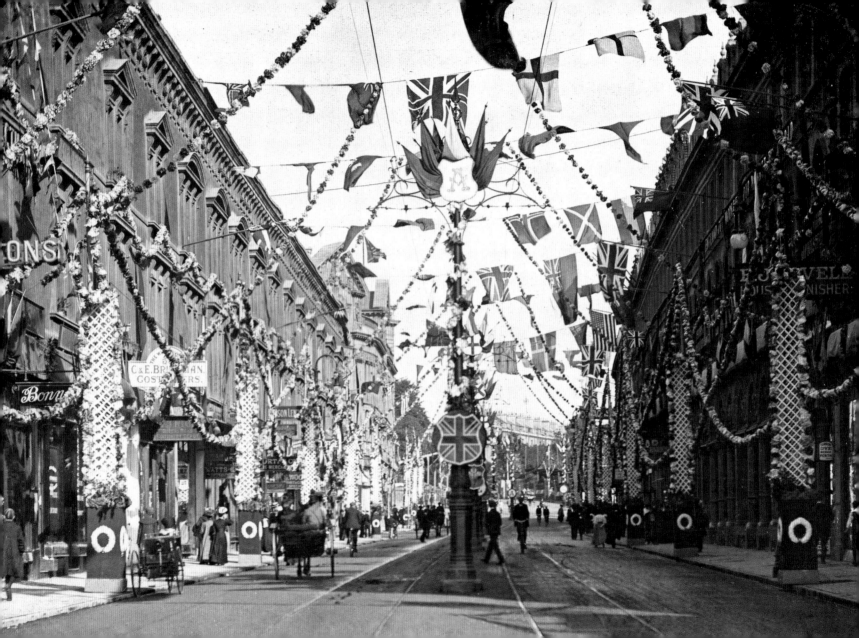

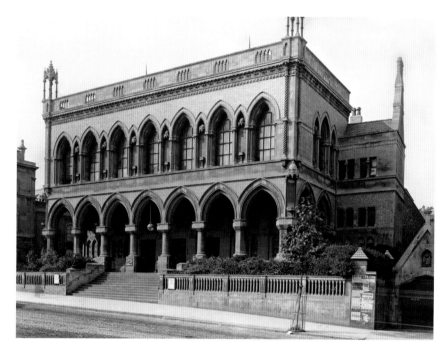

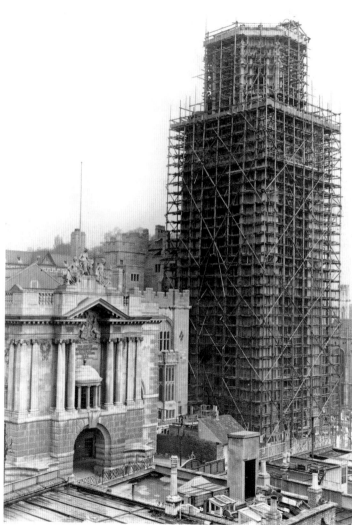

(facing) *Queen's Road, decorated for the Royal visit of King Edward VII,* 1908, photograph

(above) *The former Museum and Library, now Brown's Restaurant, Queen's Road,* c.1890, photograph

Bristol is known for its university, founded in 1909 from a University College established in 1876, catering to some 300 male and female students. The Wills Memorial Tower was added in 1913-25 as the centrepiece of a new main building. The tower is 215ft (65m) high, with a monumental open belfry stage holding Great George, one of the heaviest bells in the country. The University of Bristol has produced 11 Nobel laureates, and now has around 23,000 students. The University of the West of England (UWE) has around 30,000.

(right) *The Wills Memorial Building under construction,* c.1920, photograph

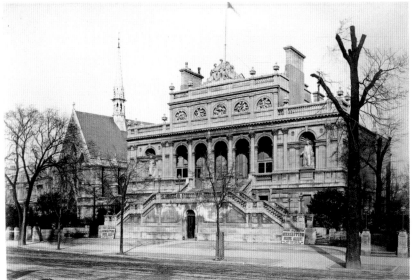

(above) *The Royal West of England Academy (RWA), Queen's Road,* c.1890, **photograph**

The Royal West of England Academy (RWA) and the Victoria Rooms opposite seem naturally to announce the entrance from the City to Clifton. Yet until the late 19th century, this area was an awkward no-man's land, where the road was briefly bordered by a belt of parkland and nursery gardens. The RWA was formed in 1844 as the Bristol Academy for the Promotion of Fine Arts, and raised the money to open its imposing permanent galleries in 1858. Its exterior is now much changed, for the external staircase was replaced in 1911-13 by a single-storey addition stretching the full width of the frontage. The ground-floor entrance and internal staircase are more practical, though less impressive. The Victoria Rooms was opened in 1842 as a venue for concerts, dances and public meetings. Its splendidly sinuous bronze fountains (facing) surrounding the memorial to King Edward VII were added in 1913.

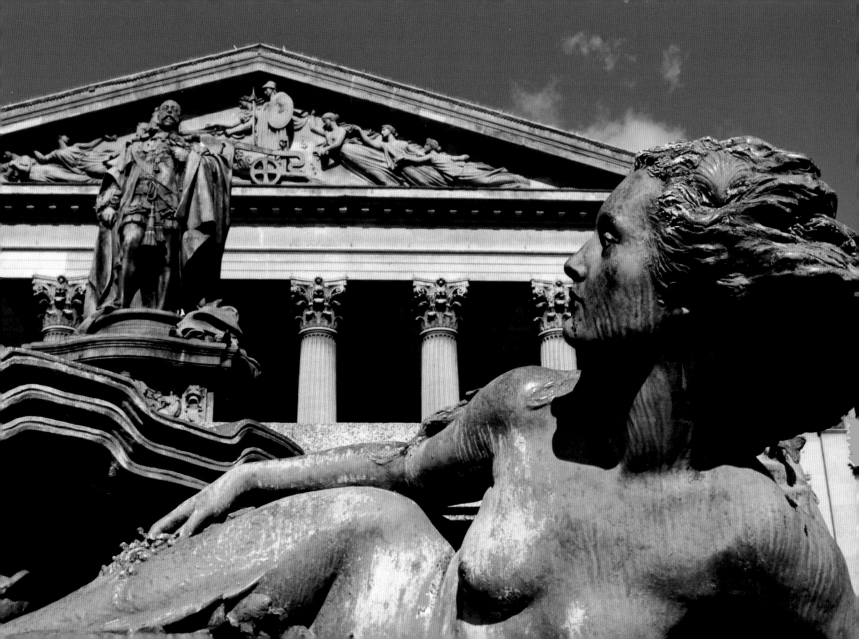

(below) *St Michael's Church, St Michael's Hill,*
c.1894, photograph

Building-site hoardings were a gift for the
Victorian advertiser. Sir Charles Halle
and Arabella Goddard gave piano recitals
at the Victoria Rooms. More intriguingly

'Mr Edwards the American Wanderer'
announced his spectacular panorama showing
in Bristol, pitching to a different audience.
Edwards was 'a Cockney of the vulgarest type'
who travelled the country showing scenes from
American life. The images were much enlarged
versions of prints or photographs, mounted on

canvas which passed between revolving drums, giving
the impression of a moving show. It was reportedly
created in the early 1860s, when interest in the
American Civil War was universal and the public
would pay for anything which went by the name of
information. The scenes were 'full of droll blunders',
a fact which proved Edwards's undoing when he made
the mistake of taking his show to New York in 1865.

(right) *The stucco plasterwork on the staircase at Royal Fort House*, 2007, photograph
(below) *Foster's Almshouses at the junction of Colston Street and Christmas Steps*, c.1861-70, photograph

Bristol is a city of hills, as any cyclist will agree. Perhaps the most picturesque is St Michael's Hill, running steeply north from the medieval heart of Bristol. The road might appear now to be unimportant, running out to the northern suburbs of Redland and Westbury-on-Trym; but it was the medieval route to Aust on the Severn estuary, from whence ferries rowed the treacherous tides across to South Wales. As this was the only way of avoiding a 40-mile detour via the bridge at Gloucester, the road was busy. St Michael's church was founded at the foot of the hill in the

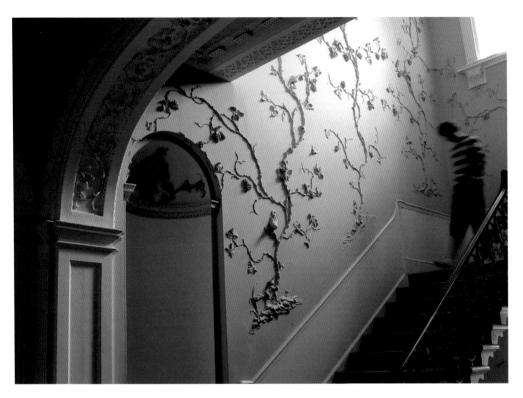

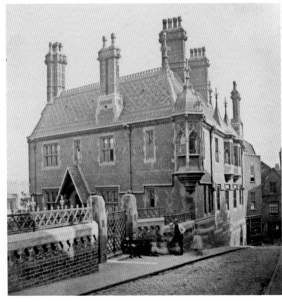

15th century, and numerous inns were opened: this was the first available place for weary incomers to rest themselves and their horses. The name of the nearest pub on the right (facing), The Scotchman and His Pack, is over 150 years old and reputedly derives from the scotches (wooden wedges) driven under the wheels of carts to keep them stationary on the steep slope. This pub and its neighbour, the Colston Arms, were built c.1695 as rented tenements to finance Colston's Almshouse, the low building with hipped roof peeping out next door. Edward Colston is perhaps the most famous Bristol merchant of the days of slavery and made his money partly from the trade, bringing controversy in recent years as the heritage of slavery has been acknowledged publicly.

(facing) *St Michael's Hill*, c.1866, photograph

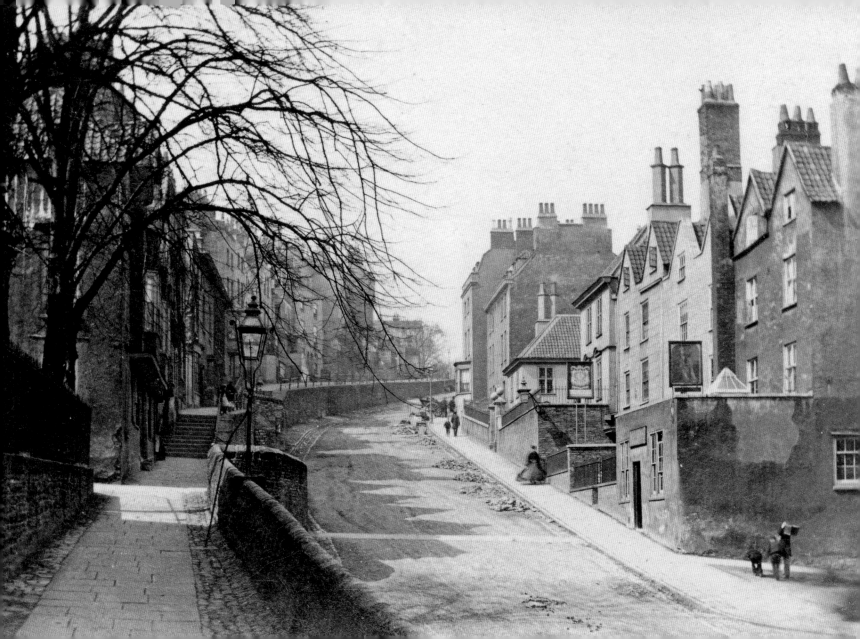

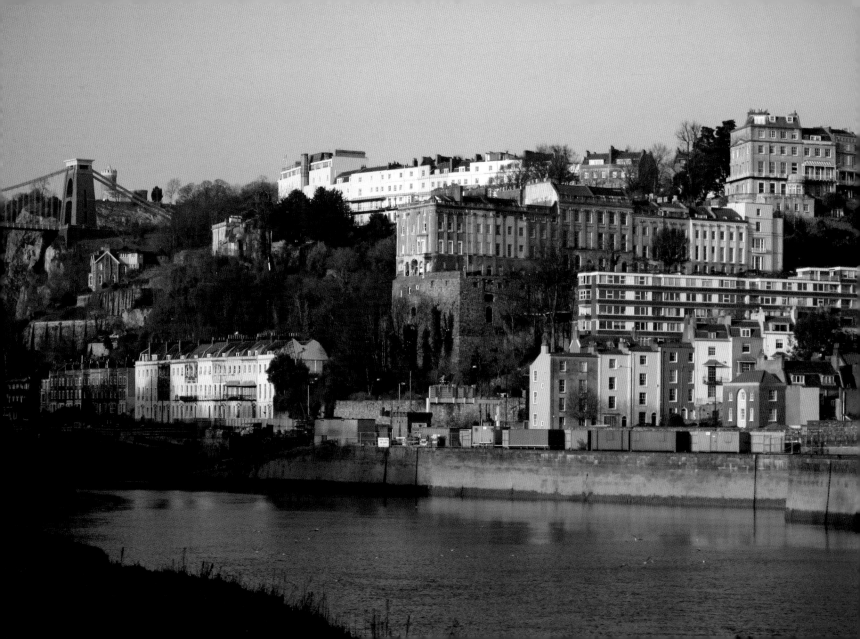

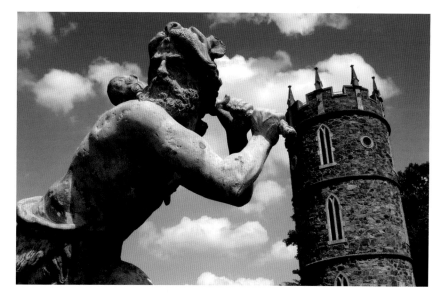

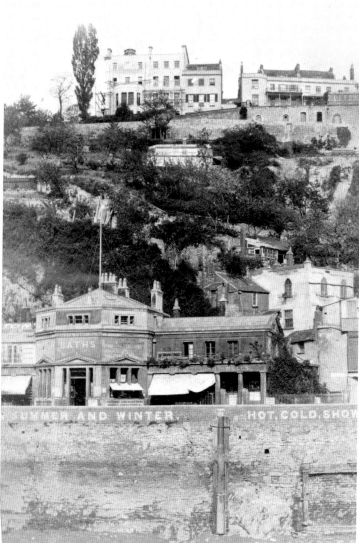

(above) *The statue and gothick tower in the gardens of Goldney House,* **2007, photograph**

Hotwells, as its name implies, is the site of a warm spring rising on the north bank of the River Avon, at the entrance to the Gorge. A spa was licensed by King Charles I in 1630, and by 1695 the water was piped up to a small pump house above the high water line. Drinking the water was reputedly beneficial in cases of scurvy, diabetes, kidney stones, inflammation and haemorrhages, scrofula, cancers, consumptions and fevers. From the 1720s smart lodging houses were developed around Dowry Square. The spa's high point was the late 18th century, when its summer season complimented the winter season at Bath, which was always far more fashionable. A new pump house was built in 1820-2, too late to halt the decline of the spa as Cheltenham and Brighton eclipsed even neighbouring Bath. The pump house was finally demolished in 1867.

(right) **R.T. Cartwright,** *The Baths at Hotwells,* **c.1860, photograph**

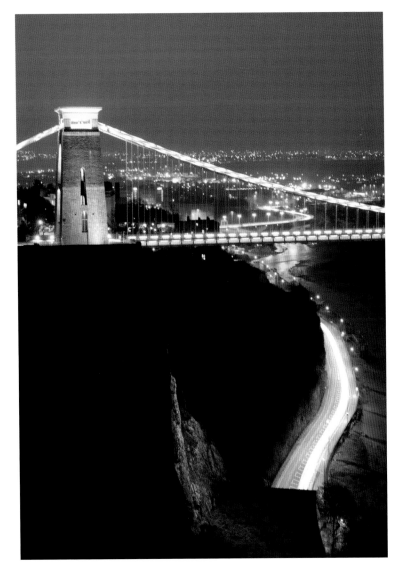

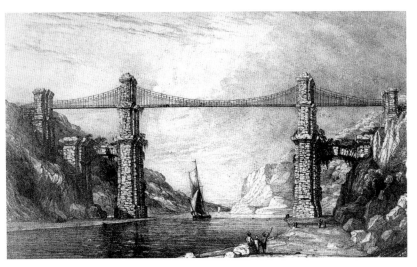

(above) *Submission by C.H. Capper, Birmingham for the competition to design a new suspension bridge,* 1829, lithograph

Clifton Suspension Bridge is the single most recognisable symbol of Bristol, genuinely iconic in a world where the term is inaccurately applied to anything new or prominent. It is Brunel's earliest and most striking design for Bristol, which he called 'my first child, my darling'. The idea began with a legacy of £1,000 invested in 1753; by 1829 it had grown to £8,000

and a design competition was held. Most entries relied on traditional techniques, such as Capper's design with rustic stone piers which could never have stood on the soft Avon mud (above). Brunel's light and daring suspension-bridge design launched from piers on the clifftops was begun in 1831, but the money ran out and the piers were finally abandoned in 1843.

(facing) *The Baths at Hotwells and the unbuilt suspension bridge in the background,* 1860, photograph

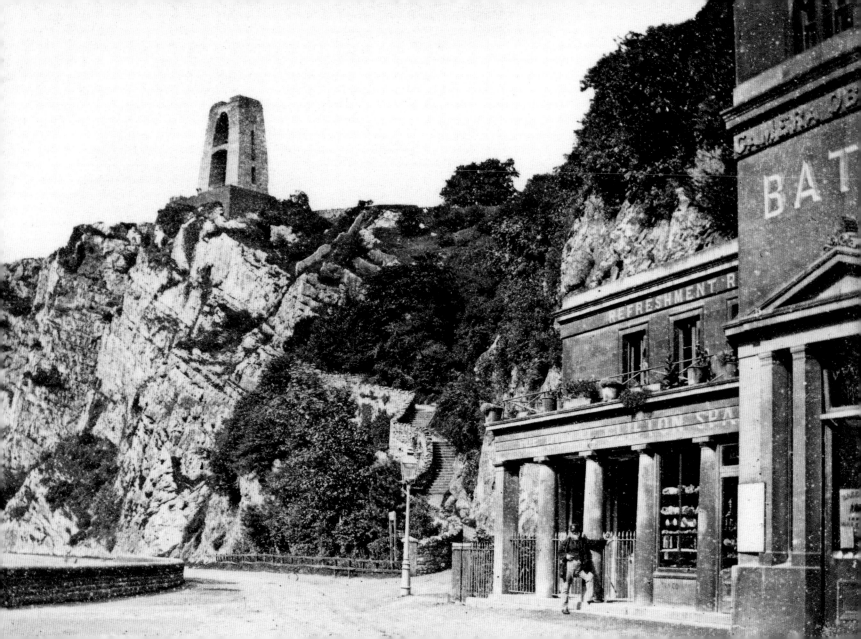

(below) *P. Smith & Son, Contractors and Decorators of Clifton make some repairs to the timber flooring of the bridge, c.1900, photograph*

Ironically it was Brunel's sudden death in 1859 that led to the scheme's revival, as a fitting memorial to Brunel by the Institute of Civil Engineers. Under the engineers Hawkshaw & Barlow, a modified version of Brunel's chain design was begun in 1863. The iron chains and suspension rods (right) had been purchased from Hungerford Bridge in London, another Brunel design. The deck was stiffened and widened to 30ft, as opposed to the intended 24ft. In May 1864 the interlocking timber plank deck was laid. A second layer of lighter planks at right angles formed the surface, enabling repairs without removing the entire structure. A pitch or tarmac coating seems to have been added by the time of these repairs c.1900 (below). The bridge finally opened in December 1864. The design was hailed as a masterpiece, the strongest chain suspension bridge ever constructed. Its visual lightness

contributes much to its fame, despite the underlying robustness of its construction. It survives almost unaltered as it was in 1864, whereas all other major suspension bridges of that first generation have been replaced or undergone major alterations. It now carries 4 million vehicles a year. Perhaps the greatest irony is that there was no pressing need to bridge the gorge at that point. Only later was Leigh Woods begun on the Somerset bank, and otherwise it enabled travellers from Long Ashton and Abbot's Leigh to avoid the Rownham ferry.

But that perhaps only increases the sense of marvel at Brunel's daring achievement.

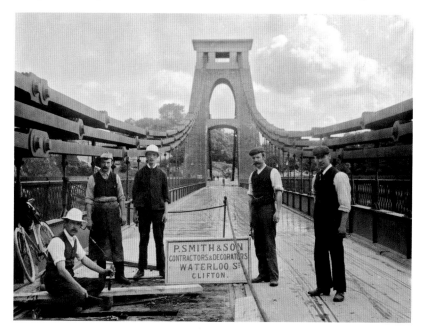

(below) *P. Smith & Son, Contractors and Decorators of Clifton make some repairs to the timber flooring of the bridge, c.1900, photograph*

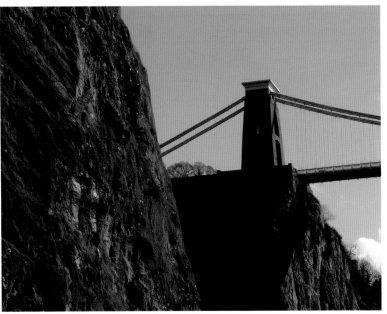

(left) *Children play on the glass-like limestone under the suspension bridge, polished by many bottoms over the years!* **c.1890, photograph**

The cliffs of the Avon Gorge have always mesmerised Bristolians, being some 260ft high beneath the suspension bridge. The hydraulically powered Clifton Rocks Railway (facing), the world's only underground cliff railway, was built in 1891-3 by Sir George Newnes, MP. The direct route up the Avon Gorge to Clifton avoided the steep hills of Hotwells. It closed in 1934, but during the war its inclined tunnel was converted by the BBC as a control centre to route radio broadcast signals. The emergency studio was never used in earnest. The tunnel and stations are preserved by a charitable trust and occasionally open to visitors.

(facing) *The lower entrance to the Clifton Rocks Railway,* **1896, photograph**

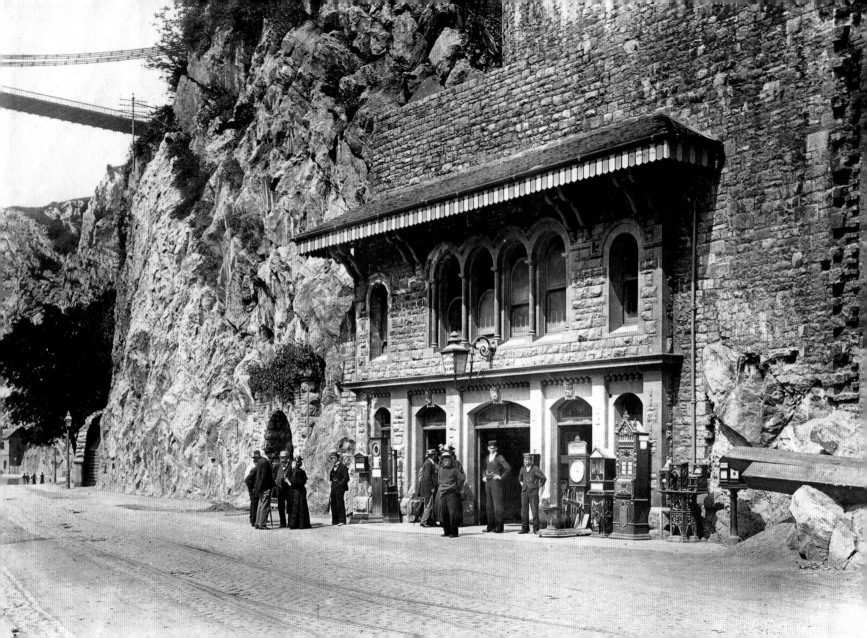

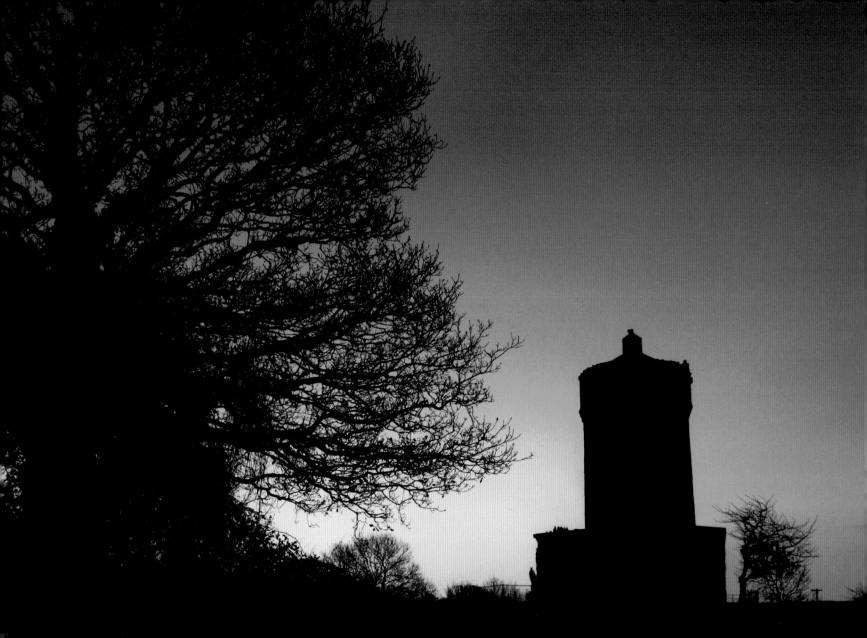

(above) *Entrance to the Cumberland Basin from Rownham Ferry before the construction of the present entrance lock*, 1862, photograph

(right) *The Clifton Observatory*, c.1830, lithograph

Clifton was always quite distinct from Hotwells, beginning as an ancient village with a small church. By the late 17th century a few merchants' houses were clustered near the church, but development of lodging houses began in earnest in the mid-18th century. The attraction was the high, airy location away from the smells and smoke of the city, and the rural surroundings which inspired artists and writers to eulogise Clifton's charms. In 1829 William West converted a derelict windmill on one of the highest points of Clifton Down for use as an observatory, installing a telescope and a timber balcony. In 1835 he added a building alongside with other astronomical instruments, and a camera obscura was added on top of the tower. It was used by artists to draw panoramic views of the gorge, and is still in use today.

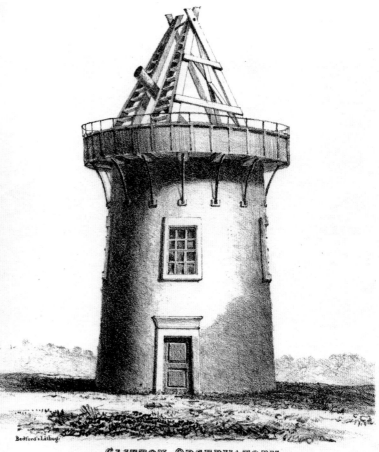

Bedford's Lithog.

CLIFTON OBSERVATORY.

(facing) *Chimney pots and ironwork, Sion Row, Clifton,* **2008, photograph**

Clifton underwent a spectacular building boom in the 1790s following the drilling of a borehole on Sion Hill to bring water up from the Hotwell. A spa and hotel was quickly built, and developers scrabbled to borrow money for new lodging houses around Sion Hill, Royal York Crescent (below) and the Paragon. In 1793 the French Revolution caused confidence in British banks to waver and Clifton's development boom collapsed, as it did in Bath and elsewhere. James Lockier, a timber merchant who was one of the biggest investors, had debts in excess of £300,000. Many houses remained half-built for a decade or more, with recovery happening only slowly after about 1805. But Clifton's fashionable golden years arrived c.1825-50 (right). Nearly all Bristol's wealthiest residents bought houses here, and many visitors stayed too: among them were Hesther Thrale, biographer of Dr Johnson; the poet Walter Savage Landor; Thomas Macaulay, the politician and historian;

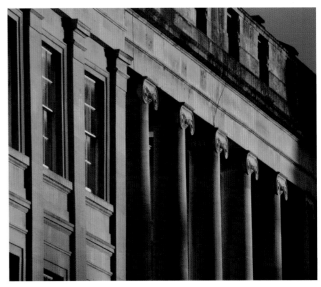

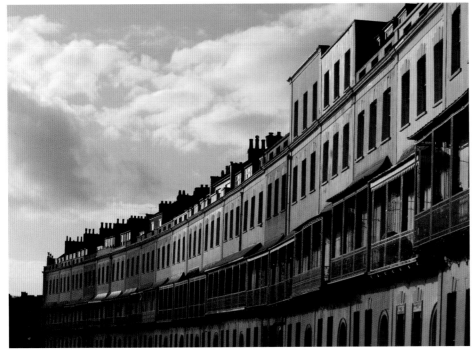

and briefly in 1837, Eugenie de Montijo, later Empress to Napoleon III. Social life centred no longer on visits to the Hotwell, which was in terminal decline – like many of those who took the waters. The Assembly Rooms at the Mall and those attached to some of the big hotels were the major social venues until the Victoria Rooms opened in 1842 (p.94). After the 1860s Clifton became more conventionally suburban, though still affluent. Sneyd Park and Stoke Bishop further north became more exclusive and desirable locations as the terrace was eclipsed by the detached villa in its own grounds. Clifton was left as the favourite haunt of wealthy retirees, developing its patina of slightly faded grandeur.

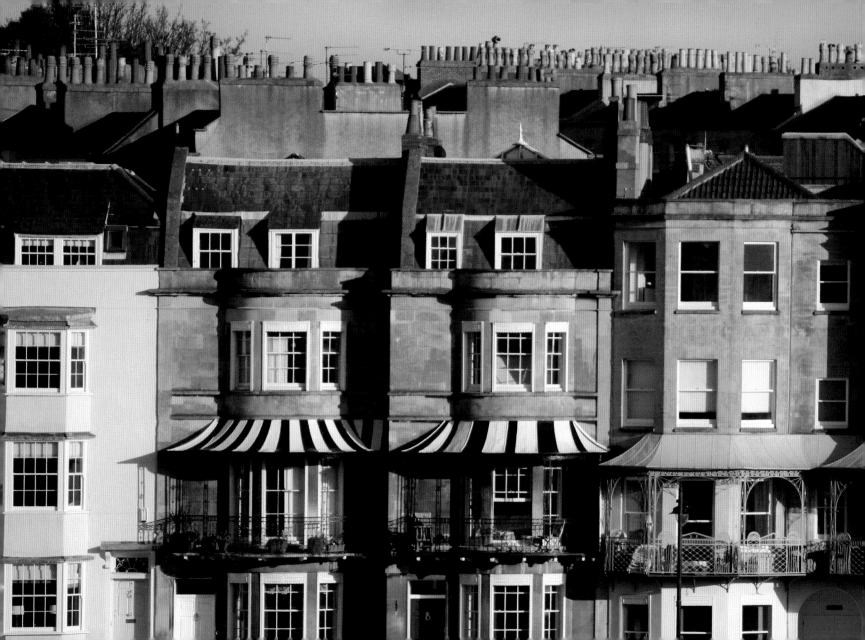

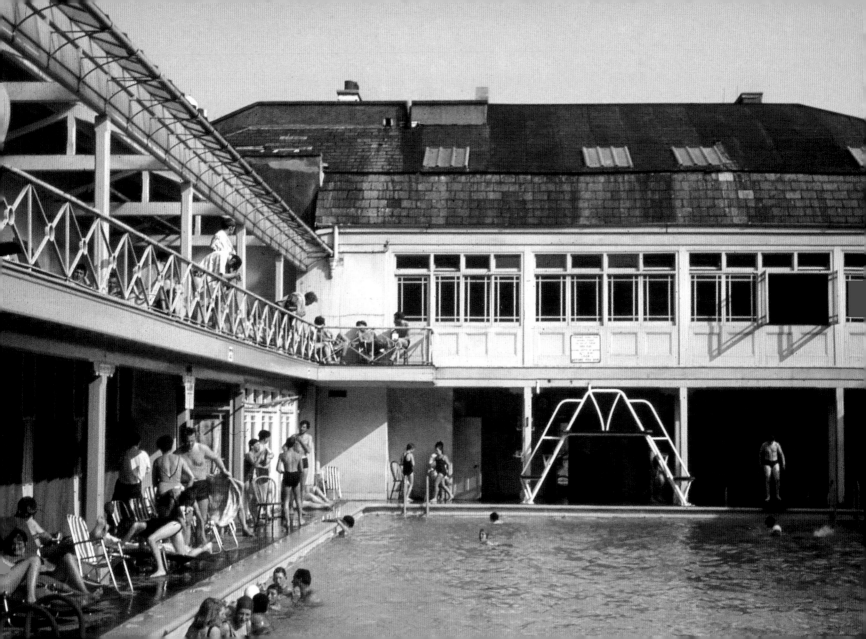

(facing) *Clifton Swimming Pool in its heyday*, c.1970, photograph
(right) *The font and stained-glass windows of All Saints church, Clifton*, 2007, photograph

Clifton's 20th-century history is chequered. It declined further after the First World War as the cost and scarcity of servant labour made the huge smoke-blackened houses unmanageable, and many were split into flats. Clifton's finely nuanced social fabric at this time is captured perfectly in the novels of E.H. Young, whose fictional Upper Radstowe is a thinly disguised portrait of Clifton. The rapid growth of the nearby university from the 1960s made the run-down houses ideal for student lets. The property boom of the 1970s and later has seen its fortunes rise again. Facilities which seemed to have been lost have recently found new life as moneyed professionals continue to move in. The Clifton Swimming Pool, built in 1849-50, is one of the oldest surviving public swimming pools in the country. It closed in 1990 and came close to dereliction before being revived as an upmarket lido, spa and restaurant in 2008.

(below) *Clifton Downs*, **1923, photograph**

Durdham Down is a broad open space sitting roughly north of Clifton. It runs west to the edge of the Avon Gorge. Its thin soil over a limestone plateau creates a characteristic landscape of undulating grassland, punctuated by scrubby clumps of hawthorns and a splendid avenue of horse-chestnuts. The boundaries are marked by elegant Victorian houses amongst belts of trees planted by the Downs Committee from the 1880s. Durdham Down is combined with Clifton Down, the green space running south from Bridge Valley Road and encompassing the site of the Camera Obscura and Clifton Suspension Bridge. Jointly known as The Downs, they form a 441-acre park. An Act of Parliament of 1861 ensures that they 'shall for ever hereafter remain open and unenclosed, and as a place for the public resort and recreation of the citizens and inhabitants of Bristol'. Runners and dog walkers, football teams, kite fliers and rock climbers share the habitat with rare species such as the Bristol Onion, Honewort, Bristol Rock Cress and Dwarf Sedge. Peregrine falcons also breed on the cliffs. Bristol Zoo was established in 1835 and remains a major attraction. It is remembered still for Johnny Morris' *Animal Magic* series (BBC Television,

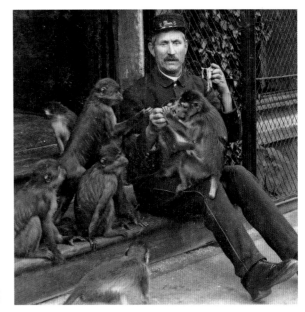

1962-83), in which Morris' zoo-keeper told stories through a series of comic 'animal' voices. He deployed the same talent in Aardman Animation's *Creature Comforts*, another Bristol production.

(above) *Feeding the monkeys at Bristol Zoo*, **c.1900, photograph**
(facing) *The zookeeper feeds a sea lion, to the amusement of the watching schoolchildren*, **c.1970, photograph**

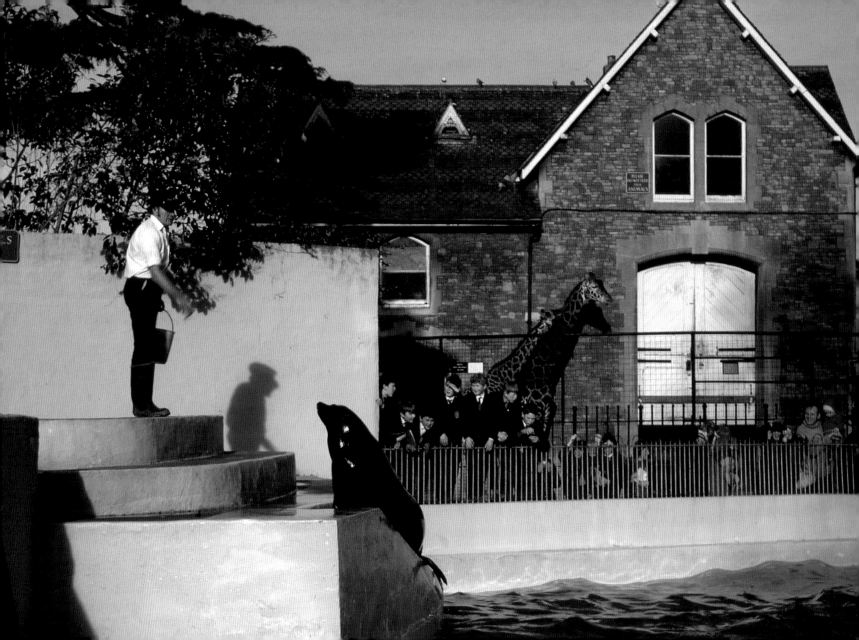

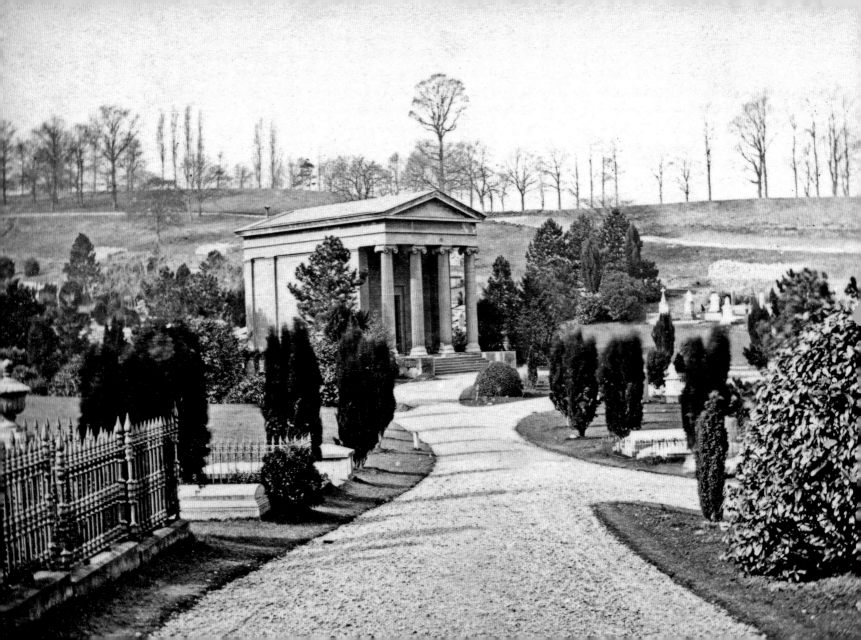

(facing) W.H. Barton, *Arno's Vale Cemetery*, c.1870, photograph
(below) *A funeral at Arno's Vale Cemetery conducted by Ware & Sons, undertakers, Dolphin Street*, c.1850, trade card

Arno's Vale Cemetery is south of the city on the Bath Road. It opened in 1839, when city churches were running out of burial space and concern was growing about the health problems of burials in crowded confines. By contrast, the vision for Arno's Vale was a spacious Arcadian landscape of hillside plots ranged amphitheatre-style around a central space. Classical chapels for Anglicans and nonconformists overlook a circular drive beyond the gate lodges. When it closed in 1998, over 300,000 people had been buried or cremated in its 45 acres. A triumphant salvation from the last stages of dereliction has turned a crumbling wilderness into a carefully

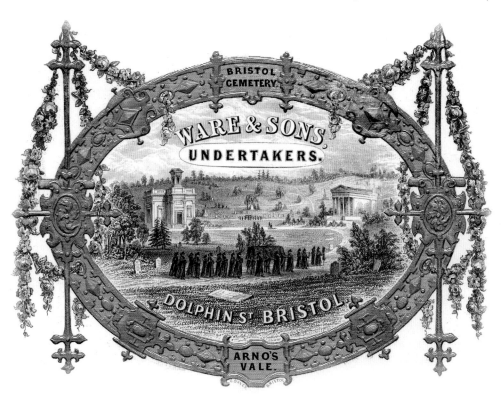

managed site where relatives can tend graves, while school parties, photographers, strollers and locals can use the visitor centre or wander among the angels and urns. It is an important wildlife habitat on the densely populated southern fringe of the city; badgers, bats and many bird species coexist with exotic trees from the original Victorian planting and meadow flowers surviving from before 1839.

(left) *Recuperating soldiers at the Auxiliary Hospital at Kingsweston,* c.1916, photograph

On the north-western fringe of Bristol lies Kingsweston (facing), a fine Baroque house of impressive drama set in a broad, grassy estate with belts of woodland, now managed as a public open space by Bristol City Council. Its designer was Sir John Vanbrugh, the owner Sir Robert Southwell, Secretary of State for Ireland to Queen Anne. Despite later 18th- and 19th-century changes to the house, Vanbrugh's dramatic conception remains relatively intact, externally at least. What is almost impossible for the modern visitor to conceive is the heroic scale of the original landscape. Several double avenues of trees radiated up to three quarters of a mile from the house, carving up the countryside into geometrical blocks punctuated by conical mounds, mazes, wildernesses and a splendid series of Baroque garden buildings, of which the best, Penpole Lodge, was demolished in the 1950s.

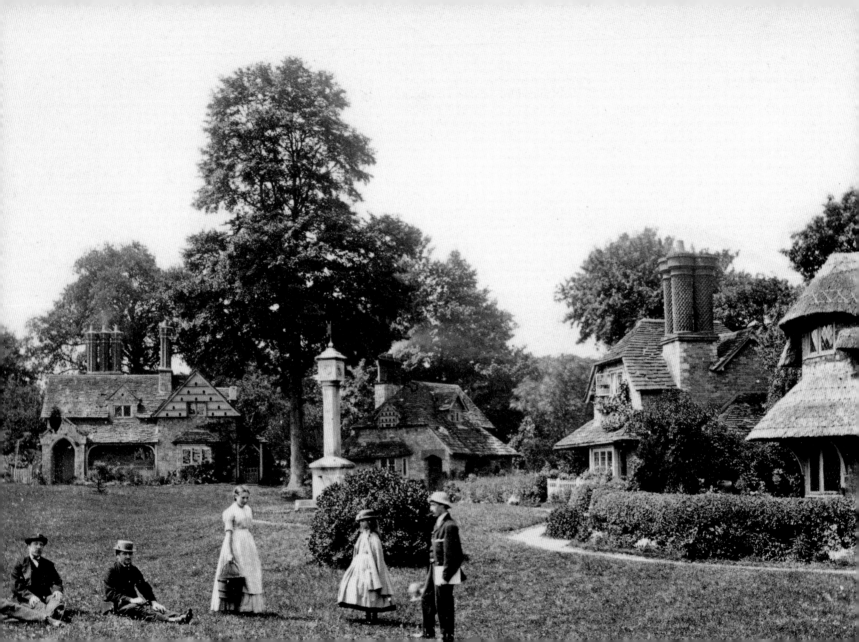

In complete contrast is the nearby estate of Blaise Castle House, also a public park with the elegant Georgian house at its centre (now a museum). What qualifies it for the name of castle is a 1760s turreted tower on a nearby hilltop carpeted with meadow flowers (below). Nearby is Blaise Hamlet, one of the great inventions of the English Picturesque. Created by John Nash and Humphry Repton in 1811 as a sort of sheltered housing scheme for retired estate workers, it is now owned by the National Trust and open without charge to the curious visitor. The houses themselves are still occupied and private. A series of impossibly sweet and almost miniaturised cottages cluster in casual informality around an undulating green, on which sits a stone pillar combining the functions of sundial and pump. The whole ensemble is hidden behind a plain stone wall: one could walk right past and miss it, which is one of its charms.

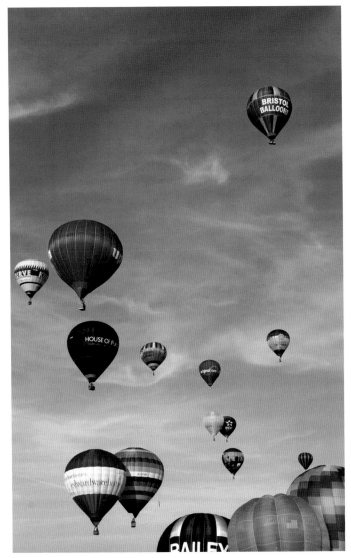

A mile or so west of the city centre, separated by the River Avon, is Ashton Court estate, a medieval manor house much enlarged over the centuries and still set in an extensive deer park. It is the venue for the annual International Balloon Fiesta which has run since 1979. The largest such event in Europe, it attracts c.500,000 people over four days. The musical nightglows (p.125) ending with fireworks are a highlight of the show. The best-known maker is Cameron Balloons based in Bedminster; they specialise in novelty balloons such as Sonic the Hedgehog, Van Gogh's head and Darth Vader's helmet. Ballooning in Bristol has a long history, beginning with a small unmanned hot-air balloon launched from Bath in January 1784, only six months after the Montgolfiers' first public demonstration in France. It landed on the slopes of Kingswood east of Bristol, a location now called Air Balloon Hill. In 1785 a Mr Decker launched a manned ascent from St Philip's, charging the vast numbers who turned out to watch.

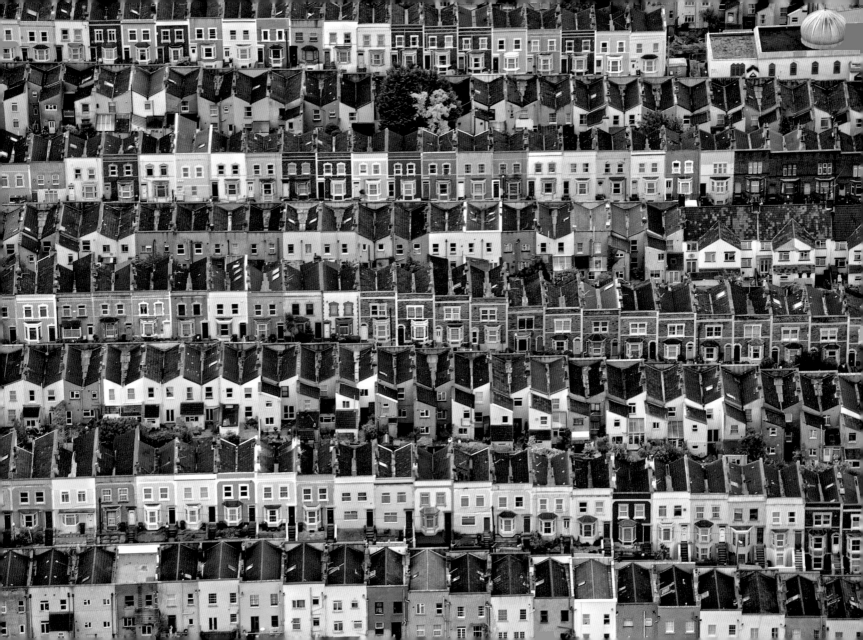

(facing) *A balloon's-eye view of rows of brightly coloured houses on Totterdown*, 2011, photograph

(right) *Mr Graham, the aeronaut, making his 29th balloon ascent from the gas works, St Philip's*, Monday 25 July 1825, poster

Bristol's prevailing westerly winds regularly send 30 or 40 balloons from Ashton Court across the city on summer evenings. Their passengers are in the best position to see what makes Bristol special. Of all the major British cities it is uniquely varied, having developed from the medieval second city with timber houses nestling among office blocks, the port weaving through its heart. The Saxon pattern of circular walls punctuated by spired churches remains clear. This rich and random eclecticism seems to attract laid-back and diverse residents; a strand of inventive, engineering, artistic, musical and literary creativity weaves through Bristol past and present, like the waters of its rivers. It is a place like no other, at once historic, modern, creative, infuriating, educated, bloody-minded, positive and animated.

In the words of J.B. Priestley, 'Bristol is a fine city. They are right to be proud of it.'

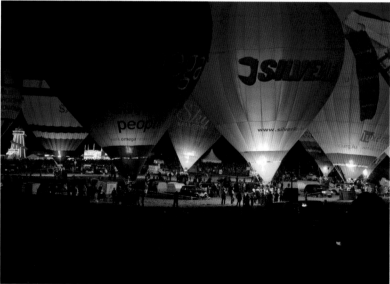

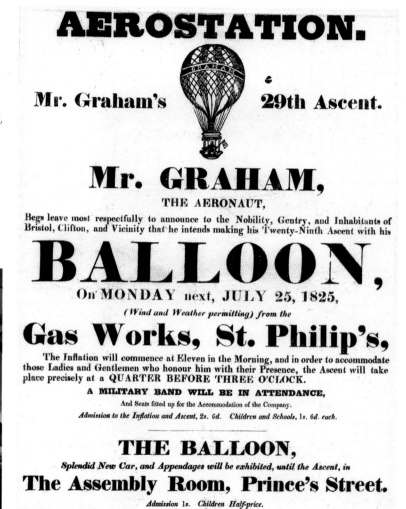

AEROSTATION.

Mr. Graham's 29th Ascent.

Mr. GRAHAM, THE AERONAUT,

Begs leave most respectfully to announce to the Nobility, Gentry, and Inhabitants of Bristol, Clifton, and Vicinity that he intends making his Twenty-Ninth Ascent with his

BALLOON,

On MONDAY next, JULY 25, 1825,

(Wind and Weather permitting) from the

Gas Works, St. Philip's,

The Inflation will commence at Eleven in the Morning, and in order to accommodate those Ladies and Gentlemen who honour him with their Presence, the Ascent will take place precisely at a QUARTER BEFORE THREE O'CLOCK.

A MILITARY BAND WILL BE IN ATTENDANCE,

And Seats fitted up for the Accommodation of the Company.

Admission to the Inflation and Ascent, 2s. 6d. Children and Schools, 1s. 6d. each.

THE BALLOON,

Splendid New Car, and Appendages will be exhibited, until the Ascent, in

The Assembly Room, Prince's Street.

Admission 1s. Children Half-price.

Tickets for the Ascent to be had of Mr. and Mrs. GRAHAM, at the Assembly Rooms; of Mr. MUTCH, Cork Tavern, Broad Quay; at the Gas Works, St. Philip's; of Mr. McDOWALL, Bookseller, High Street; at Mr. BROWNE's, Stationer, Clare Street; at Mr. LANE's Library, Clifton; and at BARTON's Hotel, Hot Wells.

C. McDowall, Printer, High Street, Bristol.

Contemporary photography by:

Chris Bertram
Chris Bertram at Flickr.com
p.31
Ian Briggs
Ian AKA-ICB Photography at Flickr.com
p.4
Dan Brown
Fortaguada at Flickr.com
p.14, 33, 34R, 41, 62, 63, 87
Norman Date
shipscompass at Flickr.com
p.61R
Myk Garton
MG/BS4 at Flickr.com
p.60
Paul Green
Paul Green at Flickr.com
p.27, 30L, 36, 37L, 46L, 78L, 113L, 124
Tim Green
The Green Album at Flickr.com
p.30R

Lee Jordan
Lee Jordan...ockermedia at Flickr.com
p.25L
Henry Lawes
henry lawes at Flickr.com
p.75
David Martyn
archidave at Flickr.com
p.9, 10L&R, 11, 15, 17, 18, 19, 21, 23, 25R, 29, 32, 34L, 35,
37R, 38, 40, 42L&R, 44, 45, 46R, 47, 49, 50L&R, 52, 53, 54,
58L&R, 61L, 65L&R, 66, 69, 73L&R, 77, 78R, 82, 83, 85L&R,
86, 89, 91, 94, 95, 96, 97, 98, 100, 101, 102, 104, 106, 108,
110L&R, 111, 113R, 117, 118, 119, 121L&R, 122R, 123,
front and rear covers
Paul Stokes
Paul Stokes at Flickr.com / Getty Images
p.81
'Aztec West' from Flickr.com
p.56
Christina West
tweeny at Flickr.com
p.70, 72, 122L, 125

Historical Images

All the historical images are © Bristol Central Library with the exception of the following:

© Bristol's Museums, Galleries & Archives p.18, 67, 118 © Bath in Time p.49, 74R © David Martyn personal collection p.105L

Index

(rear inside cover) *Panoramic view of Bristol looking south from Perry Road, c.1870-1, photograph*
(rear cover) T.L. Rowbotham, *Brunel's proposed design for the Clifton Suspension Bridge, c.1829,* lithograph

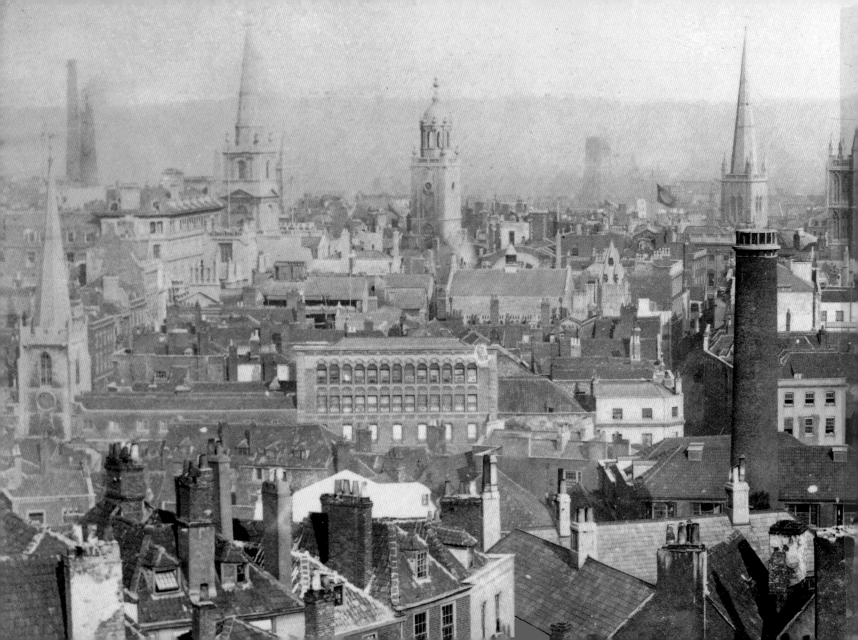